IMAGES
of America

SAN DIEGO'S
GASLAMP QUARTER

On the cover: The intersection of Fifth and E Streets is pictured here in 1923. (© SDHS, #9167)

IMAGES
of America

SAN DIEGO'S
GASLAMP QUARTER

Gaslamp Quarter Association
Gaslamp Quarter Historical Foundation
San Diego Historical Society

ISBN 978-0-7385-2865-6

Published by Arcadia Publishing
Charleston SC, Chicago IL, Portsmouth NH, San Francisco CA

Printed in the United States of America

Library of Congress Catalog Card Number: 2003111926

For all general information contact Arcadia Publishing at:
Telephone 843-853-2070
Fax 843-853-0044
E-Mail sales@arcadiapublishing.com
For customer service and orders:
Toll-Free 1-888-313-2665

Visit us on the Internet at www.arcadiapublishing.com

CONTENTS

ACKNOWLEDGMENTS

This book has been a labor of love and commitment by many people, but Stephen Silke, Gaslamp Quarter Association staff member, deserves the most recognition for managing the project. Historical information and photographs taken during the decline period have been provided by the Gaslamp Quarter Historical Foundation, from Executive Director Tracy Silberman and staff member Katie Brodeur's efforts researching CETA books compiled by University of San Diego Professor Ray Brandes, Ph.D., director of the USD CETA Gaslamp Research Project, 1978. Francine Philips provided editing expertise.

Most of the historic photographs were provided by the San Diego Historical Society and are the backbone of the book (SDHS historical photographs can be ordered through the Booth Historical Photograph Archives at the San Diego Historical Society; www.sandiegohistory.org). We are indebted to them for their assistance. In particular, thanks go to staff members John Panter, Chris Travers, Cindy Krimmel, and Carol Myers for their time, expertise, and knowledge.

Present-day photographs were provided by John Durant Photographer, Gerry Silke, Marvin Sloben Photography, and Chris Travers, with help from Centre City Development Corporation staff members Derek Danziger and Barbara Ness. Maps and graphics were designed by Debbie Reid of Reid Graphics. Thanks goes to Charles Riley of Charles Riley and Associates who donated valuable time shaping the book concept and to Michael J. Stepner, FAIA, FAICP, former City Architect, for his wonderful vision in seeing the Gaslamp Quarter's potential and sharing what makes the Gaslamp Quarter special in this book's introduction.

Finally, the Gaslamp Quarter was ultimately revitalized through the visionary and administrative efforts of the City of San Diego Centre City Development Corporation and the entrepreneurial and restoration acumen of Gaslamp Quarter preservationists, business owners, and stakeholders. This book is dedicated to them.

—Teresa McTighe
Executive Director, Gaslamp Quarter Association

INTRODUCTION

From its humble beginnings as a developer's dream, called "Horton's Addition," San Diego became the region's center for trade, commerce, and government in the second half of the 19th century. When people spoke of San Diego, they meant the burgeoning new town growing north from the wharf on Fifth Street.

By the late 1860s, San Diego was poised to be the principal city on the West Coast of the United States. Its great natural harbor promised trade with the Far East and the Pacific Coast of South America. More importantly, it was to be the western terminus of the transcontinental railroad. The city's leaders began to act on that expectation, and great structures began rising along Fifth Street, much grander than expected from a town the size of San Diego.

In anticipation of the coming railroad, San Diego's population also swelled. Adding to the excitement, gold was discovered in nearby Julian. But then misfortune paid a call. The gold cache expired quickly. Railroad owners decided Los Angeles would be the railroad terminus. San Diego's population dropped dramatically in response.

Then a flurry of activity had a major impact on the Gaslamp Quarter. The Panama Canal was set to open in 1914, and San Diego, as the first U.S. city on the west side of the canal, scheduled a grand fair glorified as the Panama California Exposition. The entire city would be refurbished to impress its guests. A new railroad station—the current Santa Fe Depot—was built. Those arriving by boat would disembark at the Fifth Street wharf, which motivated city fathers to clean up the portion of downtown south of H Street (Market) and north of K Street between First and Sixth Streets, given a distinctive name—"The Stingaree."

The Stingaree was a "Restricted District"—home to adult entertainment, such as houses of prostitution, opium dens, and gambling parlors. An infamous raid was launched in 1912 and 136 women boarded a train to Los Angeles. All but two bought round-trip tickets, many returning in time to help some of the visitors "enjoy" the Exposition. San Diego's Chinatown, adjacent to the Stingaree, was part of clean up efforts as well, as poor conditions were improved through the work of City offices such as the Health Department.

After World War II, San Diego experienced the flight of people and businesses to the suburbs, like most American cities. This exodus left what is now called the Gaslamp Quarter as home to tattoo parlors, seedy bars and saloons, pawn shops, card rooms, and locker clubs, where sailors could store their military uniforms and spend the night if they could not make their curfew. For the next 20 to 30 years, more adult businesses flooded the area—massage parlors, X-rated bookstores, and peep shows. Gaslamp became a favorite for movie companies looking for an unsavory location.

In the 1960s, a confluence of events orchestrated a change in the character of downtown's historic district once again. This time for the better. The historic preservation movement was taking hold throughout the country. In San Diego, city fathers were preparing to commemorate its 1969 bicentennial when, once again, a milestone drove the city into action. *San Diego Magazine* commissioned artist and designer Robert Hostick to suggest how we might

celebrate this anniversary. Hostick suggested the City restore and revitalize Old Town and the Gaslamp Quarter.

The City chose to focus its bicentennial resources on Old Town, but a determined group of property owners and preservationists banded together under the leadership of former city councilmember Tom Hom to revitalize the Gaslamp Quarter. They had visited similar historic districts in other cities and knew that the Gaslamp Quarter could be pivotal in the redevelopment of downtown San Diego.

In early 1974, the group petitioned the San Diego City Council for assistance. The city provided $100,000 for public improvements, rehabilitation loans, and the development of design guidelines. It was an insufficient amount of money to accomplish its purpose but enough to produce a visionary poster and three-dimensional model of the Gaslamp Quarter.

Meanwhile, in 1973, the first structure was rehabilitated at Fifth and K, the Buel-Town Company Building. Its new tenant was a popular restaurant, the Old Spaghetti Factory. Long lines to get inside proved that people would come to the Gaslamp Quarter if there were activities and attractions. Soon the first street improvements were installed at Fifth and Island and Fifth and F. Building owners responded with the restoration of the Grand Pacific Hotel and the Keating Building. Others soon followed.

The City of San Diego, under then-Mayor Pete Wilson and with goals of improving San Diego's economy, created Centre City Development Corporation (CCDC) in 1975. Work done to prepare Fourth Avenue businesses in 1983 for the Horton Plaza Shopping Mall referred to as the Fourth Avenue Project, was successful through efforts by CCDC Senior Vice President Pam Hamilton. Direction by Senior Planner Beverly Schroeder for new projects and the public agency know-how of CCDC have done much to contribute and continue the Gaslamp's economic development since 1992, specifically filling in the underdeveloped parcels of land, which did not contain preservation-worthy buildings.

Preservation architects such as John Henderson and Al Macy (who were the first to put enough faith in the blighted district, investing money and moving offices in) and Milford Wayne Donaldson (who worked in the area for 25 years) were active in community organizations dedicated to preservation and business success. These redevelopment pioneers had roles in planning, lobbying for, and designing key Gaslamp projects. They were also involved in creating the Gaslamp Quarter Planned District Ordinance (PDO) which did much to carry the character of the district during its period of significance through to the present day.

From 1975 to the 1990s, owners advocated for additional street improvements and other innovative programs, worked to have the district listed on the National Register of Historic Districts, and eventually formed a Business Improvement District. Named the Gaslamp Quarter Association, it initiated many fun-filled public events to entice people to visit the area, including tours, street fairs, parades, and concerts.

The Gaslamp Quarter is a national model demonstrating how public/private partnerships can revitalize older commercial areas. Through the extraordinary efforts of countless business owners, Gaslamp Quarter Association, Gaslamp Quarter Historical Foundation (once part of Gaslamp Quarter Association), Centre City Development Corporation, and the City of San Diego, the Gaslamp Quarter is once again the vibrant, historic heart of a revitalized downtown San Diego.

—Michael J. Stepner, FAIA, FAICP
September 18, 2003

Michael Stepner served a 26-year tenure with the City of San Diego, where he was responsible for the city's general plan and community plans for both older and newer communities. He is internationally recognized for his leadership and innovation with the American Institute of Architects, Urban Land Institute, and Partners for Livable Places. Since 1997, the San Diego Chapter of the American Institute of Architects has annually awarded the Michael J. Stepner Community Design Award to deserving planners or architects.

THE HISTORIC GASLAMP QUARTER

1850–1930

The Boom and the Bust, Stingaree District, and Early Prosperity

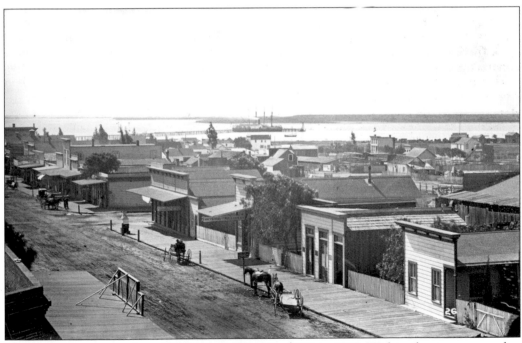

Alonzo E. Horton purchased 800 acres of land for $265 in 1867. Within three years, wooden sidewalks and dirt streets bustled with activity. Horton designed his "Horton's Addition" so that Fifth Street would become the center of commerce, and he built a pier at its foot allowing ships to deliver goods directly to stores. This 1870 photo looks south on Fifth Street in what became San Diego's Gaslamp Quarter. (©SDHS, #1431)

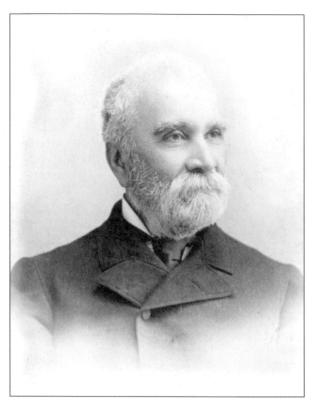

William Heath Davis was one of the wealthiest men in California by the time he was 28. In 1850, Davis purchased land near the waterfront and built pre-fabricated homes shipped via Cape Horn from Portland, Maine, on the site he named "New Town." Bad luck followed when the Great San Francisco Fire of 1851 ruined him financially, and he was forced to abandon the project. (©SDHS, #80:1173)

After attending a lecture that extolled the virtues of San Diego's beautiful natural bay, Alonzo Erastus Horton sold his successful San Francisco furniture business and headed south. He arrived in 1867 to find the remnants of Davis' $60,000 pier, a few scattered homes, and a tremendous opportunity. He declared San Diego "Heaven on Earth . . . the best spot for building a city I ever saw." (©SDHS, #UT4654)

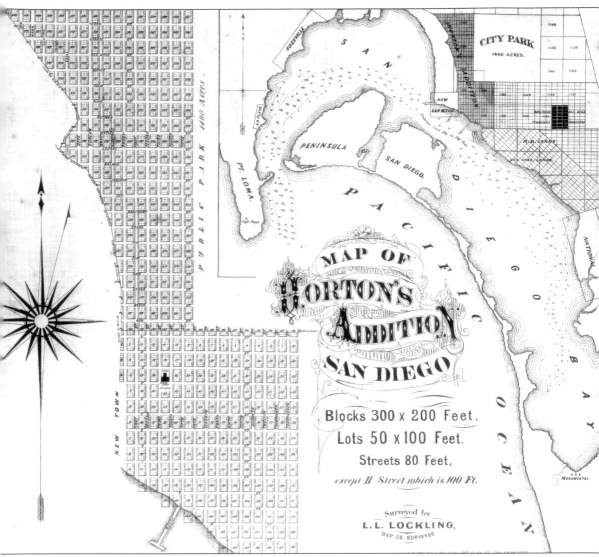

Undaunted by nicknames given to the area by townspeople, such as "Rabbitville" (after of its chief inhabitants) or "Davis' Folly" (after Davis' failed attempt), Horton declared intentions to build a city near the original New Town. San Diegans scoffed, thinking Horton a fool for the attempt, but he had experience laying out "Horton's Addition." In Wisconsin, he had previously founded Hortonville, which is still a town today. A creative marketer, he traveled back to San Francisco, opened a land office, and began selling lots. He promoted the virtues of San Diego's climate and provided free whitewash to anyone buying a lot and building within a year. Soon, New Town's white buildings glistened when viewed from the ships on the bay, making it enticing to seafarers. (©SDHS, #3822-1, detail)

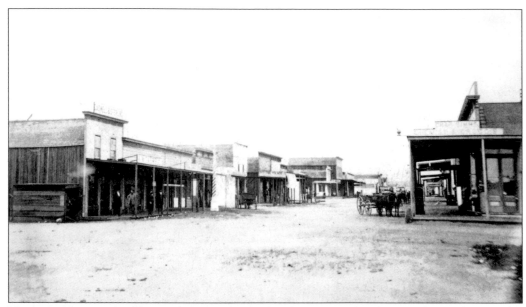

Horton's dream to build a modern city by the bay began to take shape. Taking advantage of Horton's offer of free whitewash, small wooden buildings begin to appear along Fifth Street. The next ten years brought more residents and businesses. (©SDHS, #14883)

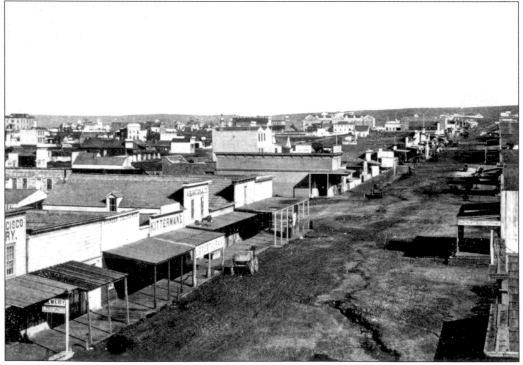

By 1877, the bayside town was lively, and it was clear Horton's Addition was a success. Most of these rough buildings didn't last long, as investors began to realize that the town was here to stay. They either resold the land at a profit or replaced crude buildings with more sophisticated structures. San Diego's first real estate boom was underway. (©SDHS, #1659)

Alonzo E. Horton's real estate transactions were so successful he complained of having too much money to count. He became a partner in the City's first bank, the Bank of San Diego, in part to help him manage his money. This building was the first of more elegant structures to come, built just three years after Horton's initial purchase of 800 acres. (©SDHS, #10523, detail)

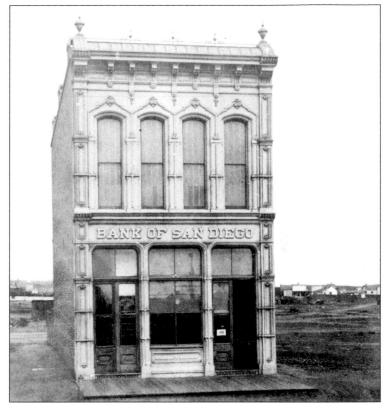

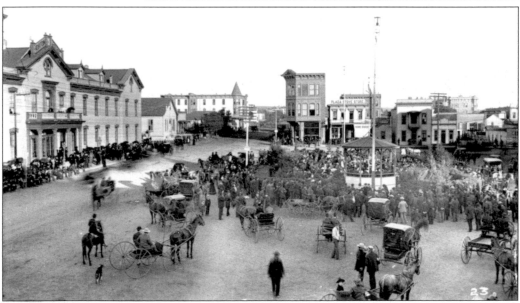

Horton's dream of building a beautiful bayfront city had come true less than 20 years after purchasing the land. It was Horton's desire that Horton Plaza, seen here in 1885, would forever remain a public park. Horton Plaza Park is still a gateway to the bustling commerce of the Horton Plaza urban shopping mall. To the left was Horton's pride and joy, the Horton House Hotel. (©SDHS, #1447, detail)

A photo taken in 1887 from the Backesto Building on Fifth Street shows the second floor balustrade, adorned with decorations for a patriotic parade underway. The balustrade and some grillwork were removed shortly thereafter. (©SDHS, #1424)

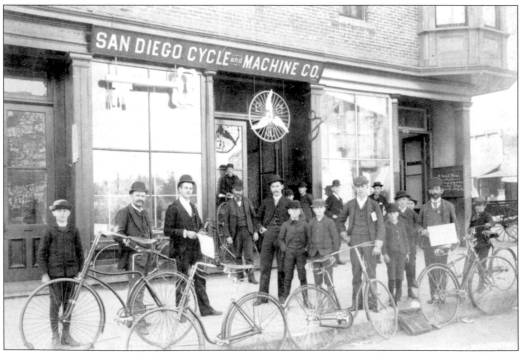

A relatively new form of transportation caught the attention of early San Diegans. Depicted here are members of the 1891 San Diego Wheelmen, a bicycling enthusiast club. They stand in front of the San Diego Cycle and Machine Company, owned by W.A. Galbraith and A.W. Birdsall. Birdsall's son later served as a major in the Army during World War I. (©SDHS, #20226)

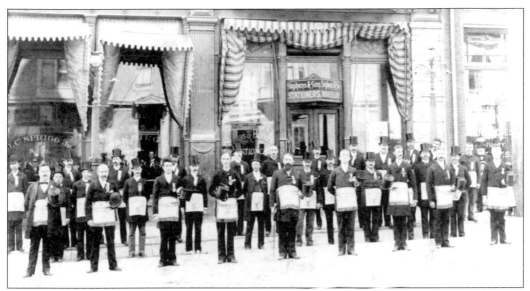

Members of the San Diego Elks Lodge wore their ceremonial aprons in front of Stephens and Sons Stationery, which sold books, notions, stationery, and fancy goods. The Elks Lodge was co-founded in 1890 by Jack Dodge, an actor, showman, minstrel, theatre manager, railroader, and politician. (©SDHS, #80:6810)

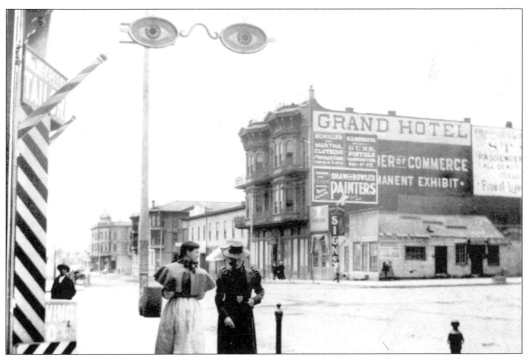

Women stroll down F Street, c. 1890, near the Grand Hotel slated for destruction when Horton Plaza mall was being built in the 1980s. It was saved by a group effort headed by S.O.H.O. (Save Our Heritage Organisation) and, with the Brooklyn Hotel, was painstakingly moved to its present location at Fourth and Island Avenues as the Horton Grand Hotel. Note the hitching posts for horses lining the sidewalk. (©SDHS, #15044, detail)

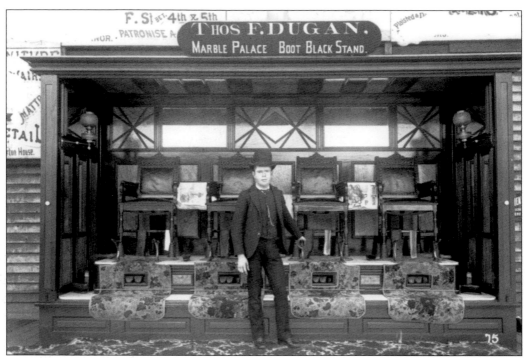

An enterprising man, Thomas Dugan took advantage of dusty unpaved streets to provide a much-needed shoeshine service to businessmen. He is featured here with his nicely appointed Marble Palace Boot Black Stand on F Street between Fourth and Fifth Streets. (©SDHS, #1359)

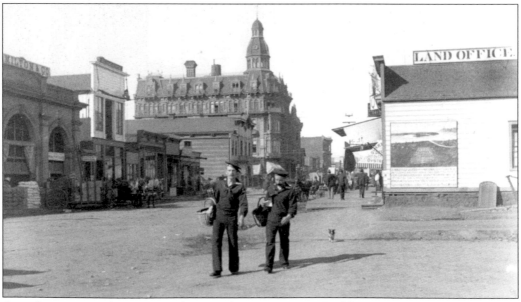

As sailors pass on their way to the pier, the Pierce-Morse Building on Sixth looks stately and well established. Built for James Pierce and Ephraim Morse (who helped Horton purchase land), the magnificent building could be seen from the ocean. Weather and age reduced it to one story before 1956, the end of what could have become a signature building of modern Gaslamp Quarter. (©SDHS, #22146)

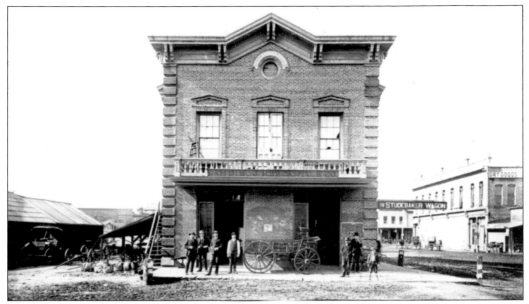

A magnificent curtain featuring San Diego Bay would rise, oil lamps would go out, and the show would begin. San Diego's elite frequented Horton Hall, built at Sixth and F Streets in 1869. George Marston and Alonzo Horton could be seen in the audience opening night. Jack Dodge leased the hall and presented two road shows a year. In the interim, it served as a mercantile building. (©SDHS, #1499)

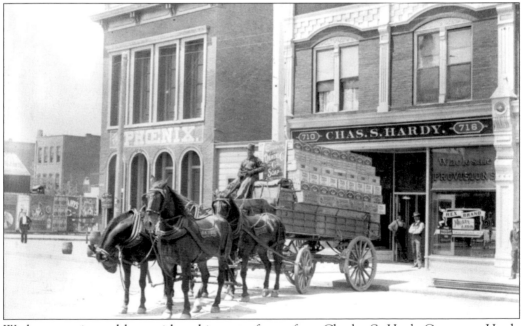

Workers are pictured here with a shipment of soap from Charles S. Hardy Company. Hardy operated a wholesale meatpacking firm, one of the largest enterprises in the city, employing over 200 men. Very active in the Republican Party, Hardy convinced the U.S. government to dredge and deepen San Diego Bay. He is also known for influencing the location of State Normal School, now known as San Diego State University. (©SDHS, #3759, detail)

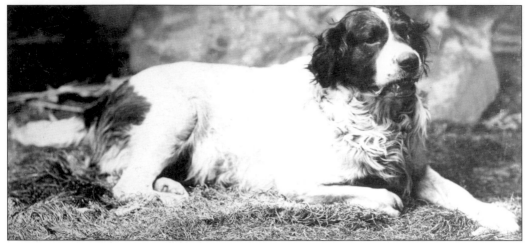

At a time when keeping a pet was reserved for the wealthy, Bum, a St. Bernard/Spaniel mix, became the town dog. He set foot in San Diego around 1885 as a stowaway aboard a San Francisco ship. Adopted by the people, he was much loved—perhaps too much, as he was even given alcohol. (©SDHS, #80:1722)

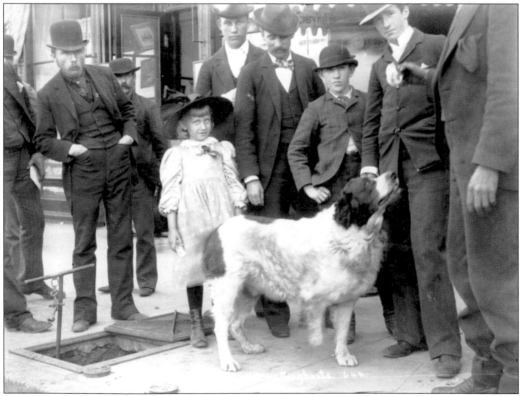

Bum became a drunkard and was sent to "rehab." Once recovered, Bum could frequently be seen attending parades and events, often up on the podium with the dignitaries. Unfortunately, during a scuffle with a rival dog, Bum was struck by a train and lost part of his forepaw and tail. After becoming arthritic, he was cared for at the people's hospital at the insistence of many San Diegans. (©SDHS, #21538, detail)

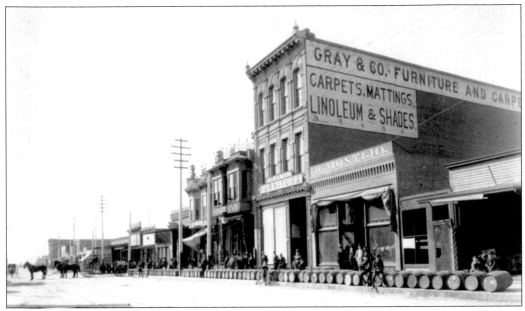

Master Craftsman George Montijo created saddles from this shop in 1888. Tom Mix, a famous cowboy movie star, was a customer. The building has been home to many businesses, including Diuchi Kawasaki's grocery, opened in 1924. Kawasaki was sent to Manzanare Internment Camp during World War II, but the business was still in his name when he returned, a rarity, and it continued successfully until 1956. This photo was taken in 1895. (©SDHS, #16781)

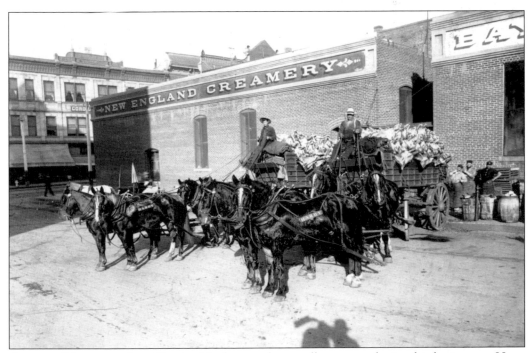

A successful meat packer, Charles Hardy was also excellent at marketing his businesses. Here, horses bearing Hardy's name pose for the camera between two of Hardy's businesses. Hardy's name appears frequently in a collection of well-preserved photographs. (©SDHS, #80:1590, detail)

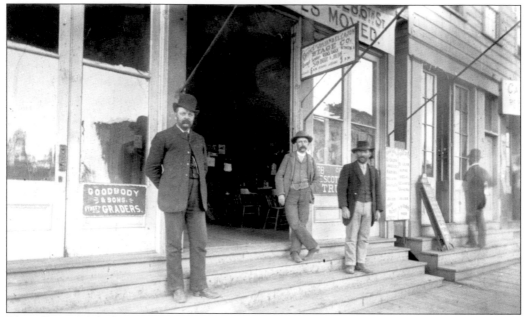

The office of Goodbody and Sons, grading contractors, on Sixth Street was located adjacent to the Julian and El Cajon Stage Company, which took residents to and from the rural eastern outskirts of the county. The ride from downtown San Diego to Julian was $3. (©SDHS, #1405)

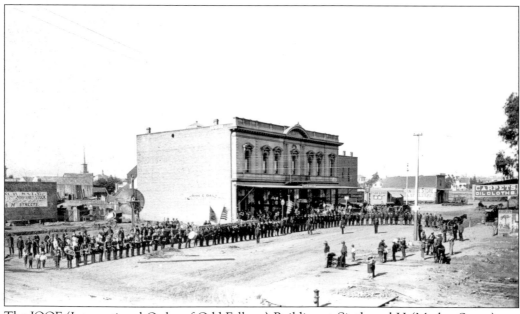

The IOOF (International Order of Odd Fellows) Building at Sixth and H (Market Street) was newly completed when this photo was taken in 1887. The gathering appears to be a parade, occurring roughly 10 years after construction. In January 1891, King Kalakaua of Hawaii died after catching a cold while attending a meeting in the building. He passed away at his next stop in San Francisco, California. (©SDHS, #1333, detail)

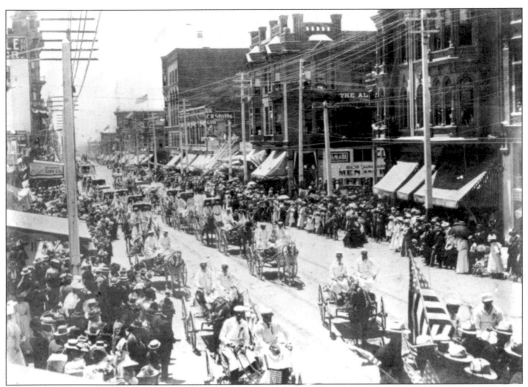

Before radio and television, parades were a popular way to gather people together to celebrate events and the accomplishments of San Diego citizenry. This parade down Fifth Street honored Charles Hardy, successful businessman and civic leader. (©SDHS, #3649)

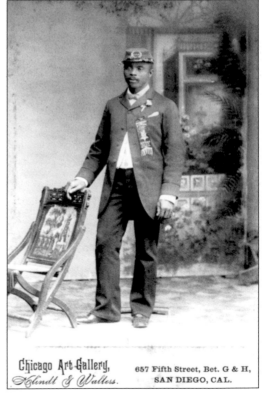

Chicago Art Gallery,
Klindt & Walters.

657 Fifth Street, Bet. G & H,
SAN DIEGO, CAL.

This grand fellow is wearing a hat and ribbons bearing the insignia of G.A.R., the Grand Army of the Republic, as a Union soldier in the Civil War of the United States. The photo was taken c. 1895 by the Klindt & Walters Chicago Art Gallery, which had offices on Sixth Street. (©SDHS, #80:3997)

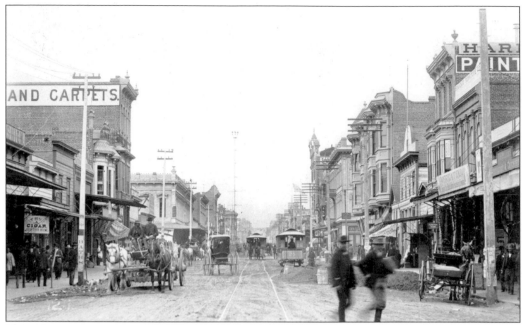

From the vantage point of Fifth and I (Island Avenue) looking north, San Diego in 1887 had become a vibrant city at the peak of its "boom" period. Notice the 125-foot Electric Arc Tower centered in the distance. A San Diego Gas & Electric employee climbed this tower daily to change the filaments at the top. (©SDHS, #1441)

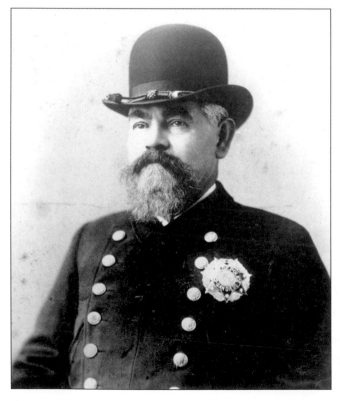

The first chief of police under a new city charter, Joseph Coyne commanded a staff of 25 and was paid $125 per month. Though he served the community well, allegations arose regarding a mining deal that went bad many years before and his reputation suffered. Coyne won the resulting court case, but experienced poor health because of it and he was demoted to courthouse night watchman. (©SDHS, #3725-B)

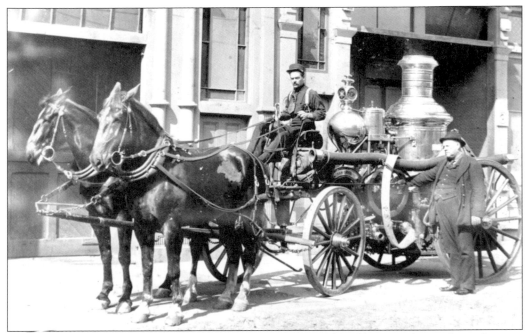

Fires were a frequent occurrence in young San Diego. Several buildings in the Gaslamp Quarter suffered moderate to heavy damage at one point or another. The arrival of a "modern" fire department in 1889 included 41 men, 11 horses, two steam fire engines, one hose wagon, two hose carts, one hook and ladder, and 4,000 feet of hose. (©SDHS, #3067, detail)

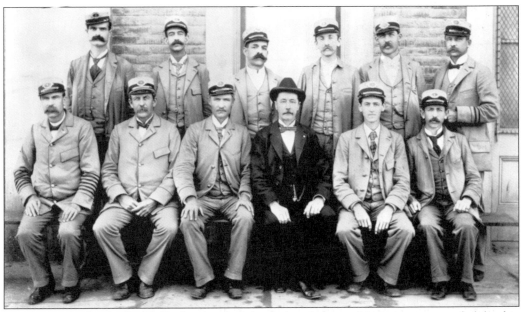

Postmaster Richard "Dick" Dodge, sitting in the center row, is shown surrounded by his uniformed Postal Service employees. Dick Dodge was the brother of Elks Lodge founder and theatre manager Jack Dodge. He and his brother were railroad men at one point, and Dick also served as City Treasurer. The brothers were married to two sisters and the four shared a home on West Ash Street. (©SDHS, #2494, detail)

George H. Schmitt, physician and surgeon, built the Dr. Schmitt Dispensary building in 1888. Schmitt lived and worked in this building and advertised "special advantages for the treatment of the deserving poor." Financial difficulties forced its sale in 1894. A new building bearing his name was constructed in 1921 and remains to this day at 951 Fourth Avenue. (©SDHS, #1982-1, detail)

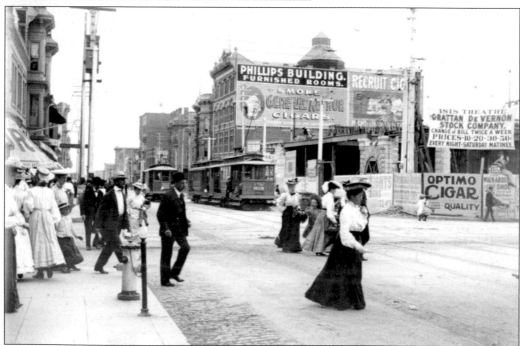

Streetcars, hitching posts, long skirts, and telephone lines all compete for survival in early San Diego. The Isis Theatre advertises near a building under construction, as cobblestones line the curb. These stones were part of a gutter system along Fifth Street unearthed during excavations in the 1970s. Some remaining stones can now be seen in the courtyard of the William Heath Davis House at Fourth and Island Avenues. (©SDHS, #803)

A hat crowned with nails, a spoon as adornment, a neckline decorative hinge, a lock bracelet, and an Ohio Steel Range belt all provided a unique way for customers to get to know the products of San Diego Hardware Company. Started in 1893 by Fred Gazlay, San Diego Hardware is the longest-running family business started in the Gaslamp Quarter and operating today. This photo was taken in 1895. (©SDHS, #10020-1)

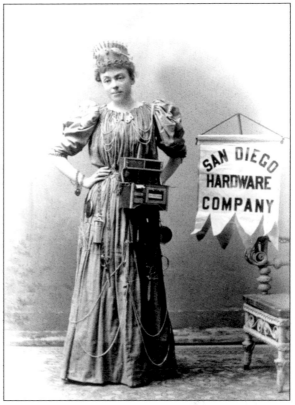

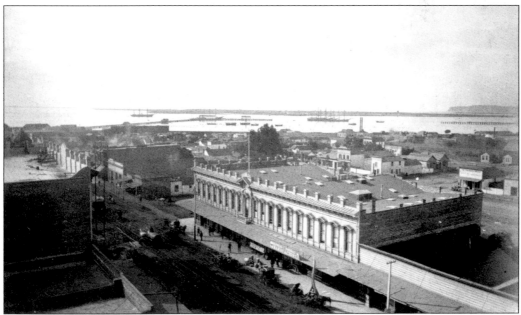

This overhead view of the Backesto Building in 1888 also shows the San Diego Bay in the background. In contrast to an earlier 1870s picture from approximately the same vantage (see p. 9), it is clear to see San Diego has grown from its origins as a dusty, wooden western town and is now a full-fledged modern city. (©SDHS, #14911)

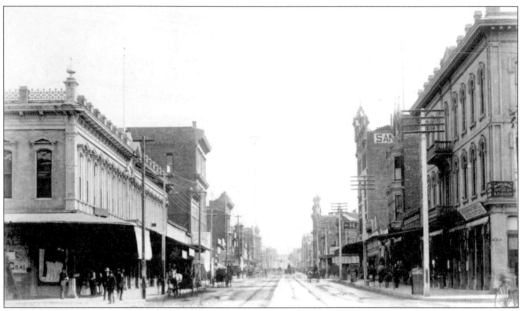

This photo taken in 1890, from the perspective of Fifth and H (Market) Streets, looks north out of the Stingaree District. The area earned the nickname "Stingaree" because it was said visitors could be stung quicker in the Stingaree than wading in the bay among the stingray fish. (©SDHS, #12309)

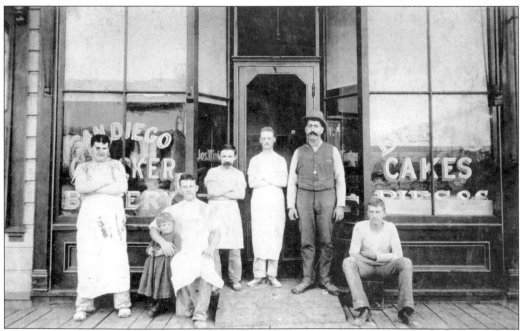

As crackers were a staple of a sailor's diet, the location of San Diego Cracker Bakery on Fourth Street near Horton's pier was perfect for brisk business. Joseph Winter used innovative technology including steam power driven machinery and an automated elevator carrying crackers to the upper floor for packing. (©SDHS, #13518)

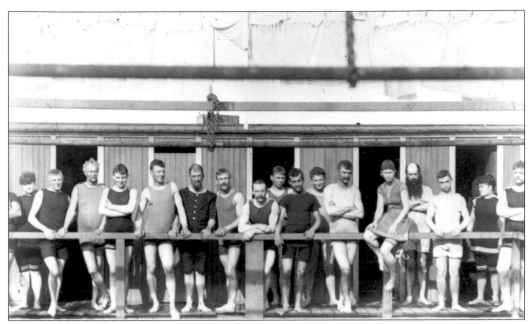

Patrons of a Fifth Street bath house pose in 1887 in the latest bathing attire of the day. (©SDHS, #1855)

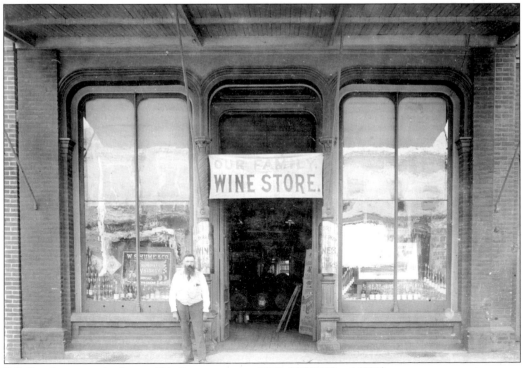

E.P. Raether poses in front of his liquor store, *c.* 1890. (©SDHS, #16780)

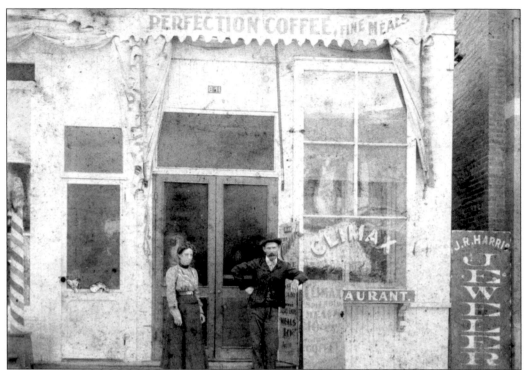

Climax Restaurant in 1895 boasts "Perfection Coffee" and "Fine Meals." The restaurant was located in the center of the Stingaree. (©SDHS, #20197)

Pictured are employees of Klauber & Levi Dry Goods in 1889. The business suffered the collapse of 60 tons of merchandise into the basement of the New Backesto Building in the late 1880s. A year later, fire destroyed merchandise worth tens of thousands of dollars, but no employees were hurt. When the building was rebuilt it was renamed the Broker's Building. Klauber & Levi were tenants until 1903. (©SDHS, #11000)

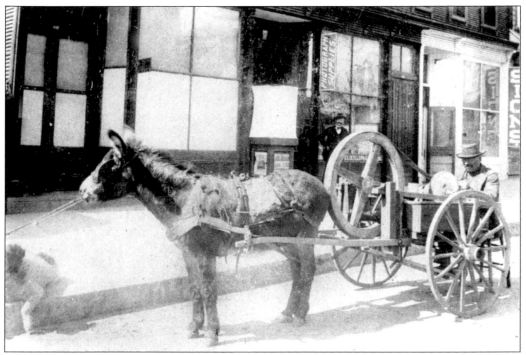

Earning a living in the 1880s often took creativity. This enterprising man made the most of the transportation and technology of the day as he traveled the town via donkey operating his mobile knife-sharpening business. It is believed the dog relaxing on the curb was the town mascot Bum. (©SDHS, #14477)

After the great real estate boom period of the mid 1880s, a significant economic collapse resulted in droves of people leaving San Diego. The population dropped from 40,000 in 1887 to 16,159 in 1890. The short-lived Julian gold rush and the late coming of the railroad were among the reasons for failure. (©SDHS, #612)

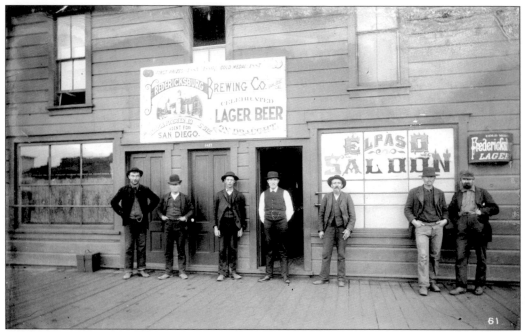

Watering holes such as El Paso Saloon proliferated in the Stingaree, and though law-abiding businessmen operated some, others were dishonest with their business practices. It was not uncommon for a gentleman to find himself "over served," leaving him vulnerable to criminal activity, including being "rolled"—robbed while drunk—or "Shanghaied"—sold to a ship as an indentured servant. (©SDHS, #1492)

In 1887, the year of this photo, an undercover reporter for the *San Diego Union* experienced the disturbing criminal activities of the Stingaree first hand. He wrote, "The eye is pained to see men lying drunk on every corner . . . it is fully as bad as the Barbary Coast in San Francisco." (Source: *San Diego Union*, Nov. 3, 1887, p. 5) (©SDHS, #1493)

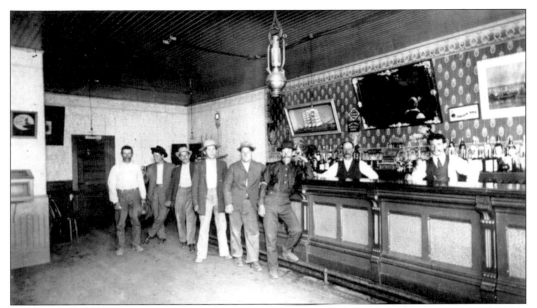

The First and Last Chance Saloon, pictured, was named for its convenient location, making it the first place to get a drink after a long journey and the last place to imbibe before leaving. Without much resistance from authorities, saloons such as the Railroad Coffeehouse at the corner of Fifth and K dispensed "Stingaree Lightning," and avoided midnight curfew on liquor sales by offering "Coffee Royal" laced with whiskey. (©SDHS, #1494-1)

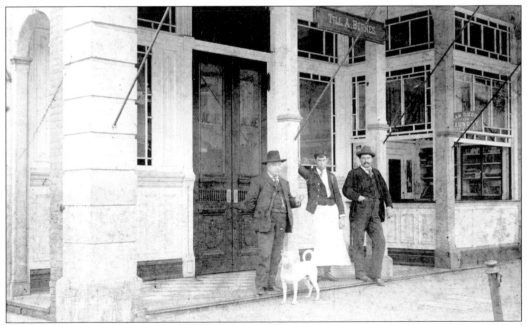

A colorful Stingaree character, Tillman "Till" Augustus Burnes learned the saloon trade at the First and Last Chance. He opened the Phoenix where he kept animals, including a bear and spiders with webs covering the ceiling. He stands on the left, next to his son Tillman Augustus Jr. and with an unidentified man in front of his last saloon, the Acme. This photo was taken c. 1889. (©SDHS, #82:12879)

Alcohol and animals were not the Stingaree's only attraction—brothels abounded. By 1888, there were at least 120 in the area. No decent woman would walk south of H Street (Market). The area became a "Restricted District," as authorities adopted a hands-off policy; as long as there were no disturbances in the area, authorities focused attentions elsewhere. (©SDHS, #14116, detail)

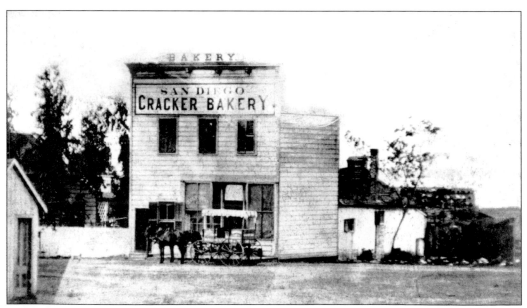

Ida Bailey, madam of Canary Cottage, ran the most elegant brothel in the Stingaree. Here its corner peeks out from the trees left of the bakery. Girls wore light make-up and beautiful gowns. Smoking and swearing were not tolerated and Bailey's establishment was frequented by many of San Diego's most respected. (©SDHS 80:1190)

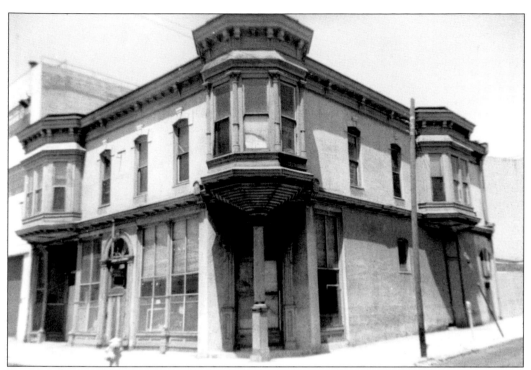

Every profession competes for supremacy, and the Turf Club run by Madam Mamie Goldstein was no exception. Among the "nicest" of the brothels in the area, the Turf, at Fourth and J Streets, vied for business with the Golden Poppy in the Louis Bank of Commerce Building and Ida Bailey's Canary Cottage. (©SDHS, #18255)

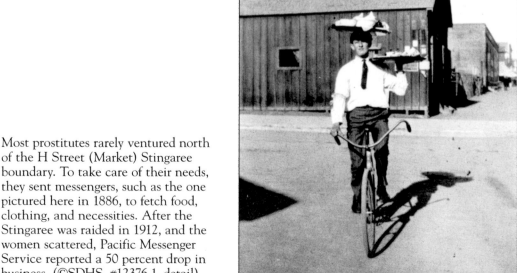

Most prostitutes rarely ventured north of the H Street (Market) Stingaree boundary. To take care of their needs, they sent messengers, such as the one pictured here in 1886, to fetch food, clothing, and necessities. After the Stingaree was raided in 1912, and the women scattered, Pacific Messenger Service reported a 50 percent drop in business. (©SDHS, #12376-1, detail)

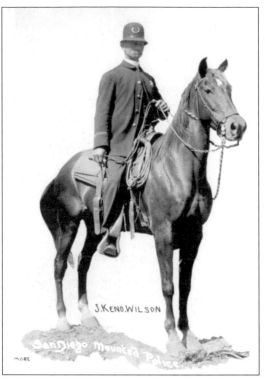

Police Chief Keno Wilson adopted and enforced the "Restricted District" policy, attempting to confine illegal activities to the Stingaree. He knew without containment, the activities would spread. The coming of the Panama California Exposition in 1915 added pressure to clean up the Stingaree, affecting a policy shift. Wilson was forced to act, but he refused until a plan was in place to provide for the women's welfare. (©SDHS, #5691-1)

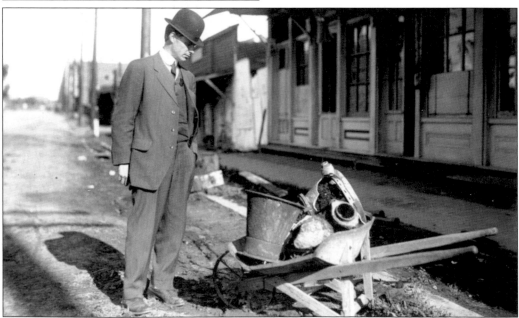

Perhaps it is appropriate that the pluming inspector was given the Herculean task of cleaning up the Stingaree. Walter Bellon, seen here examining plumbing removed from a shack, spent six years tracking down absentee landlords and forcing them to comply with public health and welfare regulations. Knowledge of life in the Stingaree is largely due to Bellon's memoirs, as those who frequented the area rarely discussed it. This photo was taken c. 1915. (©SDHS, #20128-22)

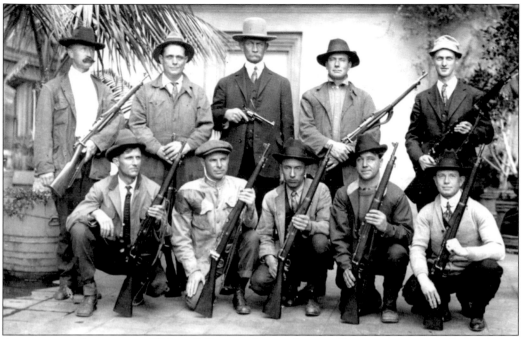

As a means of protection, Walter Bellon made sure his excellent scores as a marksman were well known. He was often accompanied by bodyguards to prevent resistance. He is pictured here (second from left, bottom row) as a member of the 1915 San Diego Rifle and Revolver Club. Police Chief Keno Wilson stands in the center holding a revolver. (©SDHS, #12702-3)

Stingaree stakeholders apparently considered Walter Bellon too good at his job. At the height of clean up, threats flooded the Health Department. Chief Keno Wilson assigned officers to act as bodyguards for Bellon, including Reginald Townsend (far left) and Walter Weymouth (not pictured). After the cleanup, Weymouth was shot in the stomach shortly after speaking with Bellon. Bellon believed he was the attacker's target. (©SDHS, #UT People: Townsend)

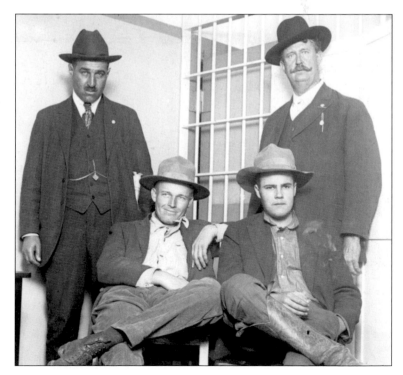

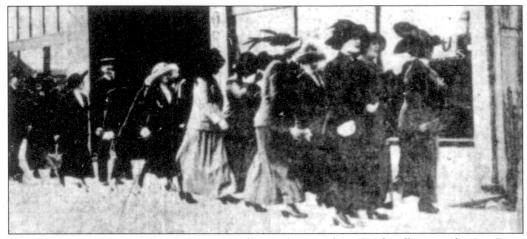

"138 Women Are Arrested in Stingaree Raid" stated November 1912 headlines in the *San Diego Union*. With a committee in place to help the women "reform," Superintendent John Sehon ordered Wilson to close the Stingaree. The arrested women, pictured here during the raid, were told to reform or leave. Most left town, but purchased round-trip train tickets, proving Wilson's assertion that closing the area would spread, not solve the problem. (©SDHS, #20128-23A, detail)

Charles Hook (right) was one of San Diego County's successful cattlemen. Pictured with Pete Ellis, he lived in Campo on land homesteaded by his mother in 1883. Charles and wife Isola traveled to San Diego by wagon for supplies. It was a two-day journey to town, but with a wagon filled with about $50 worth of goods (five months worth), it would take three days to return. (©SDHS, #17724)

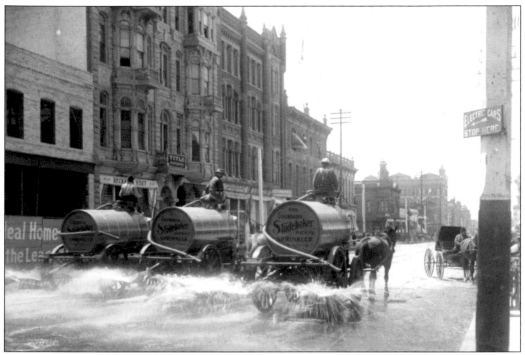

Studebaker sprinkling carts provided a necessary service for a growing city's unpaved roads in 1903. Here they are passing the Louis Bank of Commerce Building on Fifth Street, dampening it in their daily effort to keep the dust down and the city clean. Downtown San Diego's sidewalks were being paved as early as 1890 and streets began to be paved in 1904. (©SDHS, #22789)

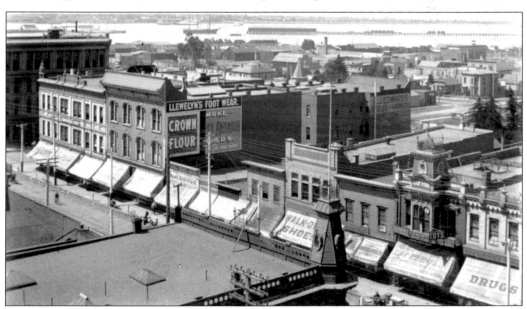

Awnings advertise stores' contents in this unique look at Fifth Street in December 1903. Llewelyn's Shoes attracts customers with a wall mural. Though San Diego is burgeoning with business and activities, in the distance, resort destination Coronado Island shows little growth. (©SDHS, #666, detail)

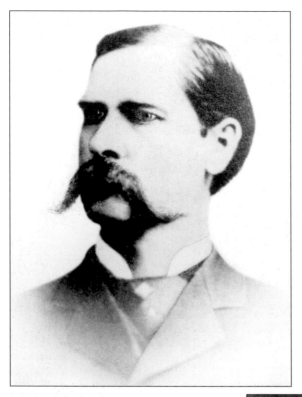

Seeking fortune in land and, perhaps, solace from events at the OK Corral in Tombstone, Arizona, lawman Wyatt Earp and common-law wife Josie arrived in San Diego between 1885 and 1887. They leased or purchased at least four saloons and gambling halls. Earp officiated boxing matches and is said to have called the first horse race at Del Mar Racetrack. After the real estate bust, they left town to find gold in the mid-1890s. (Arizona Historical Society, Tucson-11374)

Wyatt and Josie Earp eventually settled in Los Angeles, where he found work as a consultant and extra for western movies in the motion picture industry. Josie, in her memoirs, remarked that their time in San Diego was the happiest of their lives. A handsome man until the end, Earp died in his sleep in Los Angeles in 1929 at the age of 80. (Arizona Historical Society, Tucson-76623)

This picture postcard from the Klindt studios in 1895 depicts ladies engaged in card room vices abounding in and around the early Gaslamp Quarter. (©SDHS, #18198-20, detail)

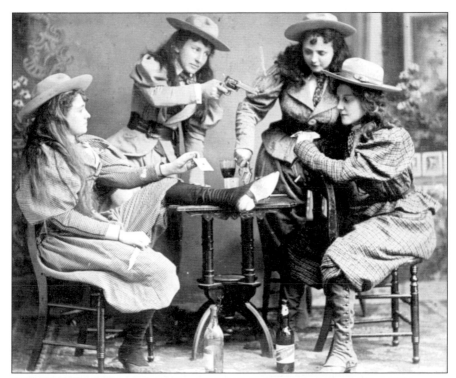

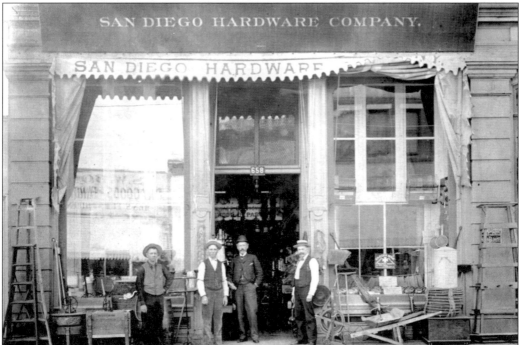

The first location of San Diego Hardware Company was constructed as an addition to the Old City Hall Building. During the early motion picture industry heyday, Rivoli Movie Theatre opened here. Later, it was the Diana Theatre and became an X-rated movie theater in the 1960s. (©SDHS, #10020, detail)

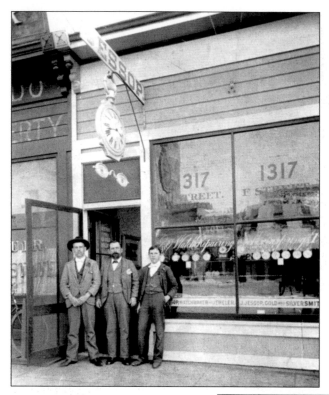

When Joseph Jessop opened this small shop at 1317 F Street (now 417 F Street) he could not have imagined J. Jessop's & Sons Jewelry Stores would become among the largest jewelry retailers in the country. Jessop, shown in 1896, was born in 1851 into a family of English jewelers. After building up his business, he designed a street clock that would become a famous San Diego landmark. (©SDHS, #1913-5, detail)

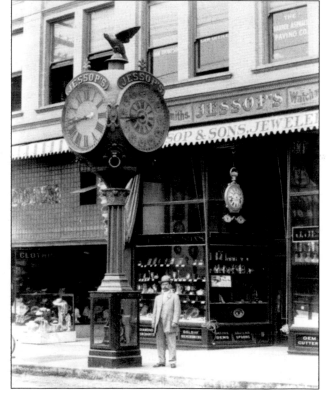

This photo was the first taken of Jessop's clock after its 1907 installation at his 952 Fifth Street store. Jessop commissioned watch maker Claude Ledger, the first Jessop employee to be hired outside the family, to execute his design. The intricate clock became famous after winning a medal at the state fair. The clock's timing has stopped three times in its history: once when hit by horses, again during an earthquake, and inexplicably, the day Ledger died. The clock is currently in Horton Plaza Shopping Mall. (©SDHS, #86:15946)

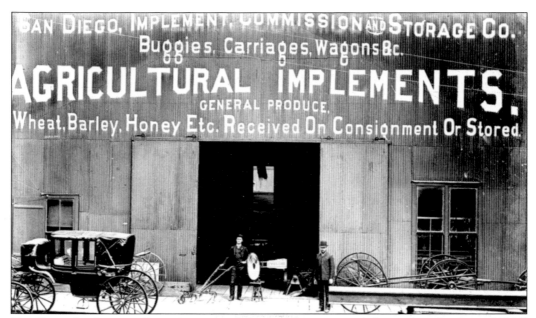

San Diego Implement, Commission, and Storage Company was located at the foot of Fifth Street near the wharf, making it a convenient location to store large vehicles or shipments of agricultural supplies. This photo was taken c. 1890. (©SDHS, #1557)

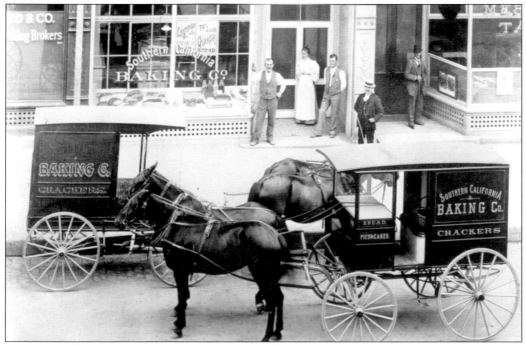

Enterprising businesses like Southern California Baking Company, pictured c. 1895, took advantage of an emerging industry. Using delivery wagons to get their goods to the stores and restaurants quickly, they capitalized on the newfound desire of people to purchase baked goods rather than make them at home. Carl Winter owned the baking company; his brothers Joseph and Leopold owned San Diego Steam Cracker Factory. (©SDHS, #3956)

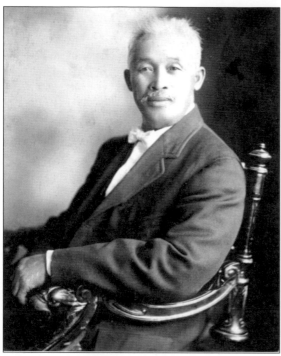

"Unofficial Mayor" of San Diego's Chinatown, Ah Quin was a highly respected member of the community. Adjusting to American customs, he cut off his queue (braided ponytail) and became fluent in English. He came to San Diego in the late 1880s to act as a labor broker. Here he raised a family and became wealthy as a successful farmer and business owner selling, ironically, Japanese goods. (©SDHS, #79:315)

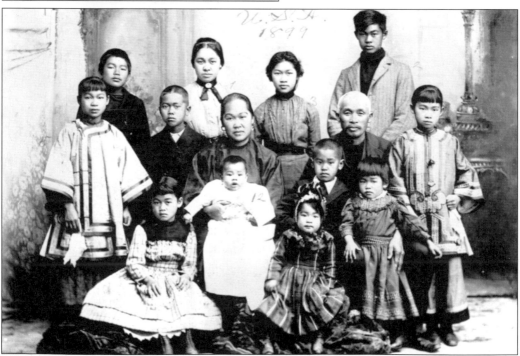

Ah Quin and family, pictured here, were among many Chinese immigrants living in San Diego. After leaving poor homeland conditions they found life in California difficult, dealing with bigotry and more poverty. These immigrants carved out a community in the seediest part of town, the Stingaree. Most Chinese led quiet lives, availing themselves of support groups like the Chinese Benevolent Society. (©SDHS, #3512-1)

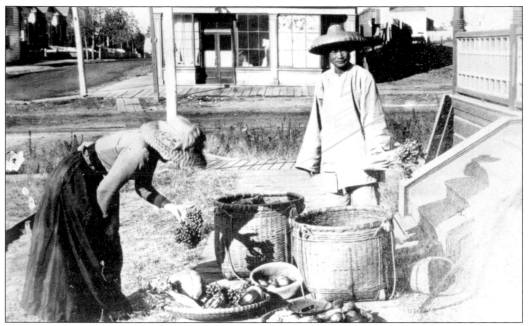

Hardworking Chinese immigrants struggled to make a new life in a foreign land. They provided much needed services, including fishing, farming, grocery stores, laundries, and restaurants. Though known also for running opium dens and lotteries, most worked hard at creating a new life for themselves and their families. (©SDHS, #14718-4)

A Chinese junk, the *Mon Lei*, is pictured at full sail near San Diego Bay. A small community of Chinese fisherman operated just off the bay near the Stingaree, providing fresh fish to the townspeople of San Diego and living in shanties built on stilts along the waterfront. (©SDHS, #80:5540, detail)

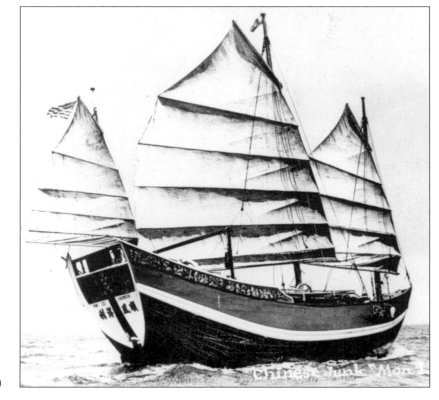

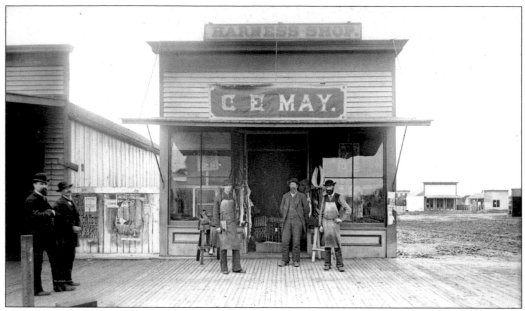

The harness shop of C.E. May shown c. 1887. Notice the plank sidewalks that still existed in this section of Horton's Addition at that time. (©SDHS, #1496)

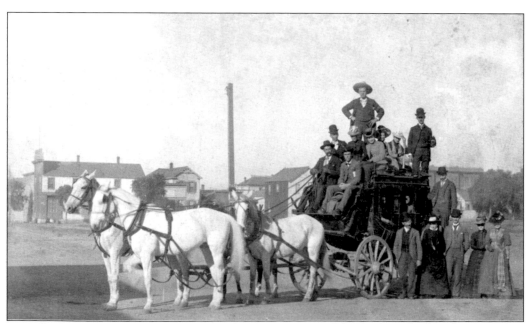

A Tally Ho, or day-trip stagecoach like this one would adventure around San Diego giving passengers a one-day road trip. This picture was taken at Fourth and G Streets in 1889. (©SDHS, #92:18691-4)

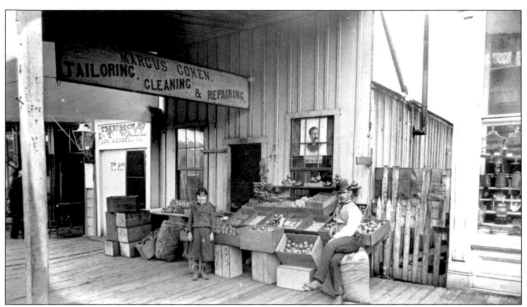

"The Hole in the Wall" saloon is pictured here next to a small produce mart and Marcus Cohen's Tailor shop. With other saloon names like "Old Tub of Blood" and "Seven Buckets of Blood," it's not hard to imagine why the Stingaree earned its notorious reputation. (©SDHS, #1497)

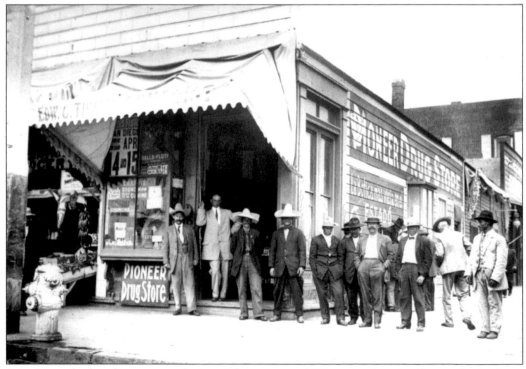

San Diego had a diverse population. This group of Hispanic Americans stands in front of the Pioneer Drug Store. A Spanish sign reads, "La Botica Mas Vieja en el Estado." (©SDHS, #UT 1510)

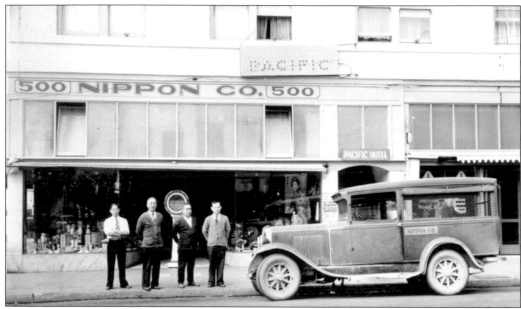

Japanese immigrants came to San Diego to look for work during the boom years of the 1880s and created successful businesses. From left to right, Kubo Kichita, Shima Hyonosuke, Suzuki Tokujiro, and Imamura Shigenobu stand in front of their cooperative, Nippon Company, formerly the location of Till Burnes' Acme Saloon. (©SDHS, #13721-11)

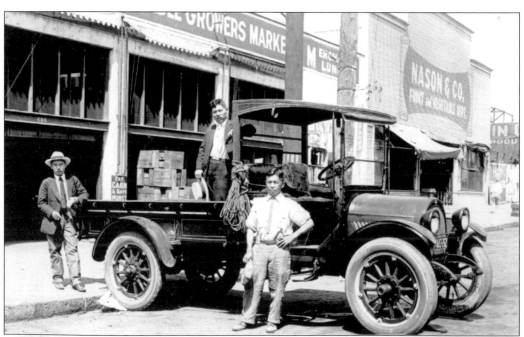

As with many immigrants, Japanese workers found little acceptance and formed Vegetable Growers Market to sell produce because Caucasian brokers refused their products. They were called Issei Cooperatives; *Issei* refers to the generation of Japanese natives who immigrated to the United States. Many Issei were farmers or owned grocery stores along lower Fifth Street, and they contributed much to the economy and dinner tables of San Diego. (©SDHS, #13721-25)

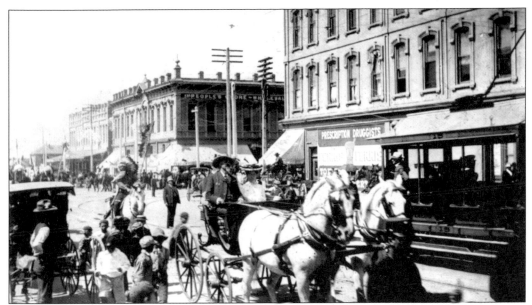

Eleven thousand people turned out in 1902 to view William "Buffalo Bill" Cody's "First, Last and Only Visit to San Diego," billed as his "au revoir" appearance. The spectacle included a parade, Wild West show, artillery drill, and famous western entertainer "Buffalo Bill" himself. It was not to be his only performance in San Diego though, as he returned eight years later for an encore "au revoir" performance. (©SDHS, #14472)

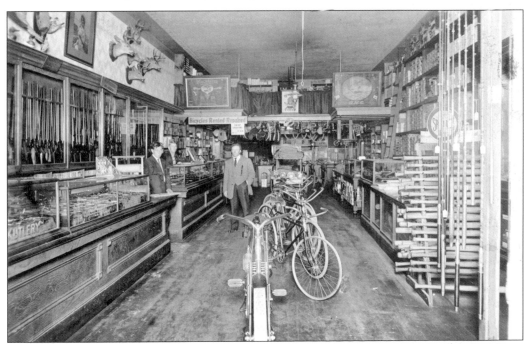

An interesting mix of merchandise included bicycles, guns, ammunition, sporting goods, fishing tackle, golf clubs, tennis rackets, and baseball bats. Owners Stanley Andrews, Archie Aldridge, and Max Toews carried a broad range of sporting equipment inside the San Diego Cycle and Arms Company. (©SDHS, #79:215)

A solitary wagon is parked on Sixth Street facing the waterfront as the trolley and cement sidewalks showed a city making progress. With the advent of the telephone, San Diegans experienced profound change in the coming of the new century. (©SDHS, #2926)

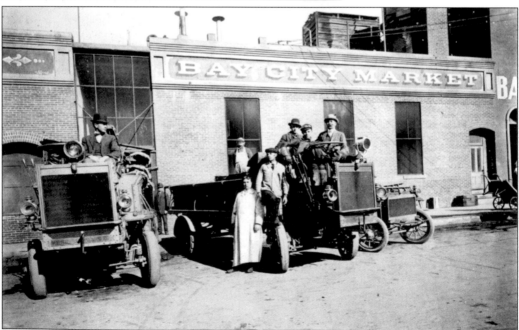

In 1914, these trucks transported goods from Charles Hardy's Bay City Market. The horses were soon out of a job. (©SDHS, #12276)

In 1903, these members of a flag drill team limber up for the day's performance. (©SDHS, #79:676)

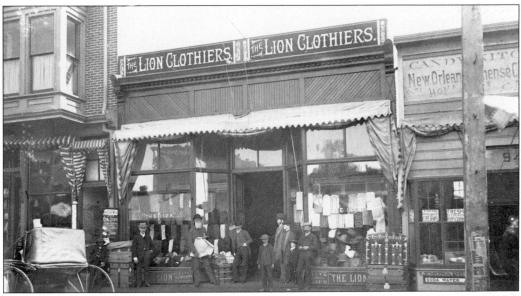

Lion Clothiers, a San Diego institution for almost a century, at its first location at 945 Fifth Street in 1886. Founded by Isaac Kuhn, Lion Clothiers had several locations, continuing business in the Gaslamp at the Samuel Fox Building at Sixth and Broadway into the 1970s. Many credit its longevity to the business acumen of Samuel I. Fox, Kuhn's brother-in-law, who acquired the business when Kuhn died in 1898. (©SDHS, #1367)

Inspiration for today's current signature "Gaslamp" street lights can be seen lining Fourth Street in this November 1912 photograph. These lamps used electricity to illuminate the busy street adjacent to the Lawyer's Block Building as Fourth met E Street. The U.S. Grant Hotel towers above Broadway on the left. (©SDHS, #80:3707)

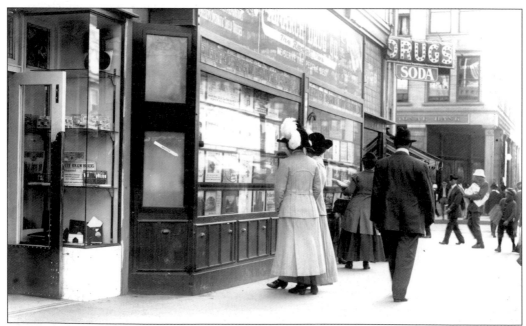

This *c.* 1914 Ralph Stineman photograph captures a simple moment, window-shopping, among the activities of busy San Diegans. (©SDHS, #91:18564-2229)

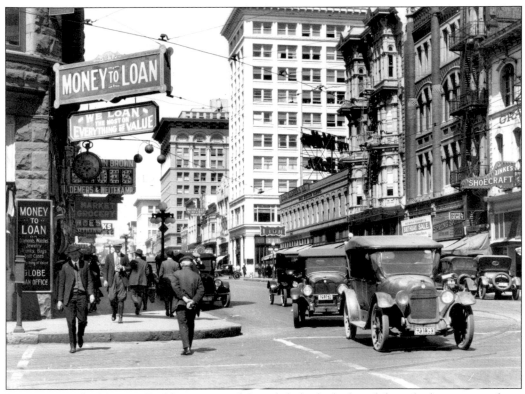

At one time, the Keating Building, pictured front left, had a locker club in the basement, where sailors could get a hot shower and change into their "civvies." On the right, the ornate Louis Bank of Commerce Building can be seen without its twin Eagle towers, which had burned in an earlier fire. (©SDHS, #S-K3-10)

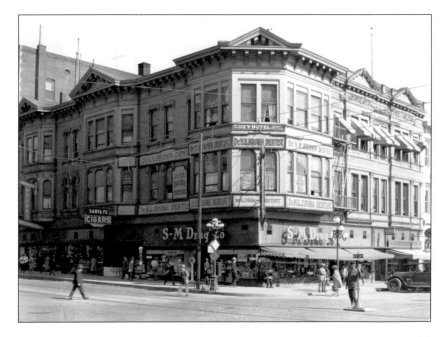

The Cosgrove Building rounded the corner of Fourth Street and D (now Broadway). It no longer stands, having been replaced by a more modest brick structure. Notice the traffic control officer standing at his post in the middle of the street. (©SDHS, #1990-1)

New San Diego Junk Company sells used tires in 1918. Clearly the horseless carriage was becoming the transportation of choice. (©SDHS, #6938)

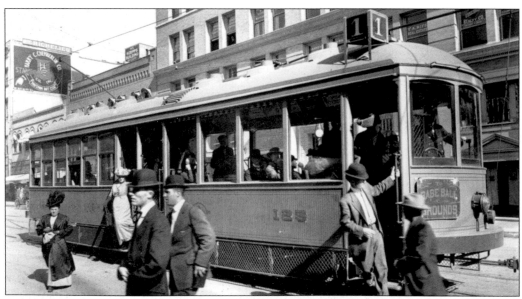

Unknown to most contemporary citizens, San Diego once had several streetcar systems. The first public transit system opened in 1886 using horse-drawn cars. This was eventually replaced by the first electrified trolley on the West Coast. John D. Spreckels created the San Diego Electric Railway Company in 1891, which was modestly successful until 1949. Even Bum the Dog is said to have used the streetcars. (©SDHS, #7787-B, detail)

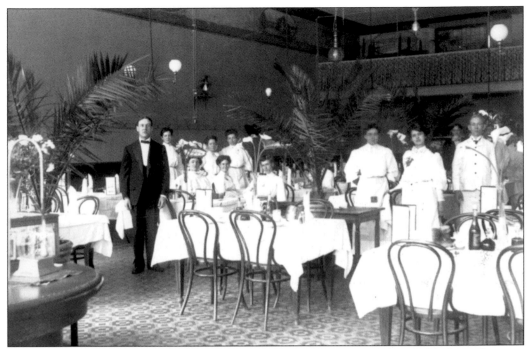

Waiters and staff of the Dalton Building's Manhattan Restaurant (939 Fifth Street), await customers in this 1910 photograph. The building also contained the Manhattan Hotel, which later became a house of ill repute. In the basement was a speakeasy during the Prohibition era. (©SDHS, #17760).

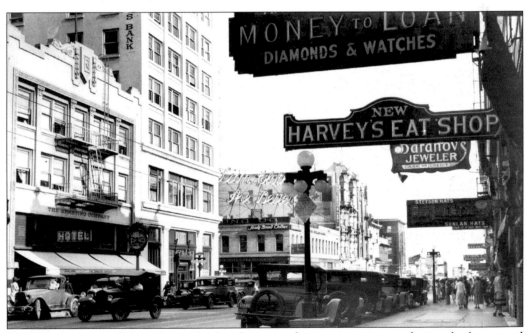

By 1920, the automobile had completely taken over downtown streets, replacing the horse and wagon. New challenges arose for city officials, such as driving regulations and parking. Notice the inverted street light globes. (©SDHS, #81:12078)

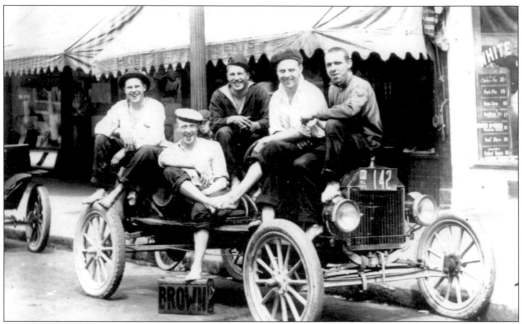

A group of young men perched aboard a motorcar pose for the camera in 1915. (©SDHS, #80:7455)

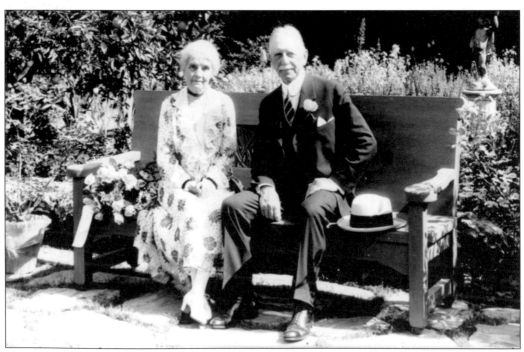

George and Anna Marston, owners of Marston's Department Store at Fifth and F Streets, celebrate their 50th wedding anniversary in 1928. Married in the late 1870s, the couple was responsible for initiating changes that have had a long-lasting and immeasurable effect on today's city. Among them, George was the first executive director of the San Diego Historical Society. (©SDHS, #90:18137-3)

SOUTHERN GASLAMP QUARTER
Walking Tour Buildings 1–7

Sandbags line the streets in the Gaslamp Quarter in approximately the same location as today's Gaslamp Quarter Gateway Arch, spanning Fifth Avenue at J Street. In the 1870s, the San Diego Bay high-water line extended close to the foreground of this photo. At the end of his life, when he was well into his nineties, Horton used to sit in a wagon at this location, proudly welcoming ships and visitors to "his city." And proud he should be, for the city he began in 1867 is now widely known as "America's Finest City," and a portion of Horton's Addition is beloved as the Gaslamp Quarter. (©SDHS, #3692)

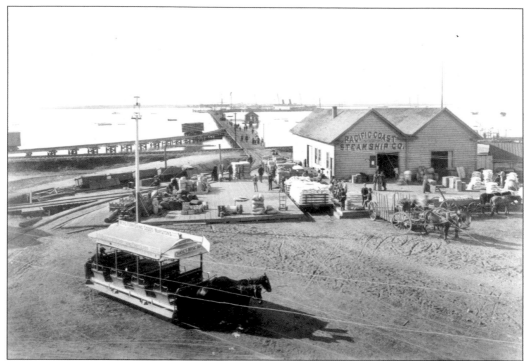

Pacific Coast Steamship Company is shown at the foot of Fifth Street, c. 1890. Alonzo Horton's pier can be seen reaching out into the bay, enabling ships to dock in the deeper part of the bay and offload goods for delivery and, later, directly onto a railcar system. (©SDHS, #7867).

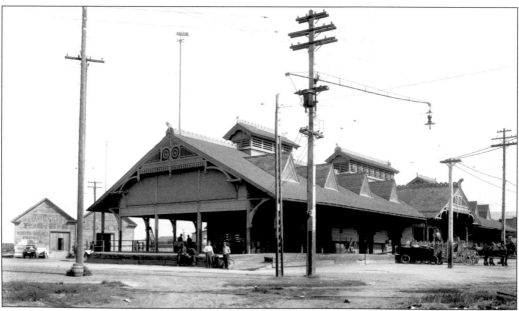

In this 1913 photograph, the original buildings can be seen in the background, dwarfed by the addition of a large terminal created to serve passengers disembarking at the Fifth Street Wharf. The terminal building was cut in half in 1919 to make room for the tracks of the San Diego and Arizona Railroads. (©SDHS, #455)

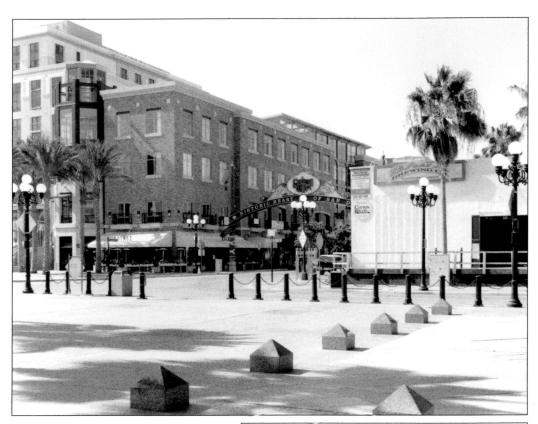

Railroad tracks and the San Diego Trolley now pass through the area where Pacific Steamship Company once stood. In later decades, Harbor Drive and the San Diego Convention Center, built on a landfill, would bring in thousands of visitors annually, just as sailing ships did a century before. Nothing remains of the Pacific Coast Steamship Warehouse leading away from what was once among the busiest piers in California. Walking Tour Building #1 (©Travers-SDHS 2000/100.188)

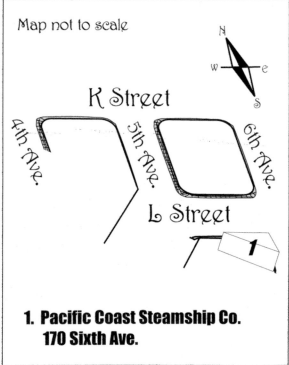

Map not to scale

K Street

4th Ave.

5th Ave.

6th Ave.

L Street

1

**1. Pacific Coast Steamship Co.
170 Sixth Ave.**

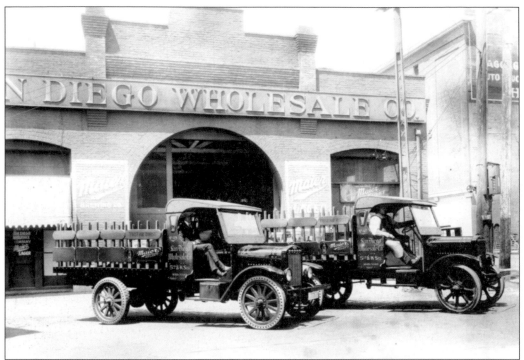

Just up Fifth Street from the Pacific Steamship Company, San Diego Wholesale found this location a convenient spot to receive goods and deliver to their customers by truck throughout the city in 1922. The building was designed by longtime San Diego architect William Sterling Hebbard who arrived during San Diego's boom in the late 1880s. (©SDHS, #8511)

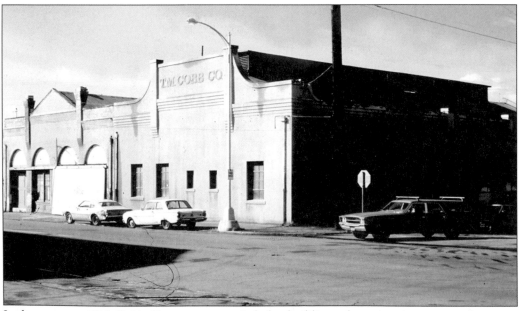

In later years, TM Cobb Company occupied the building, also using it as a warehouse to store goods delivered from ships. This building became the subject of a fierce fight between preservationists and developers in the 1980s. (GQHF)

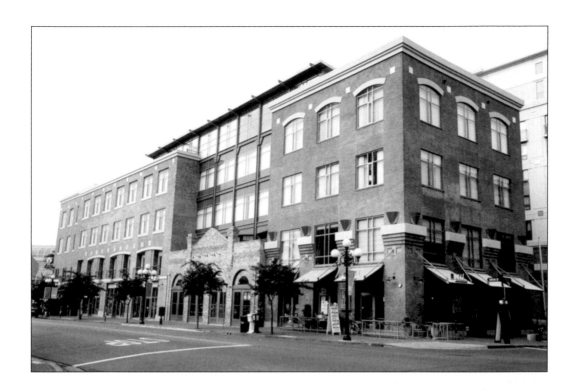

The warehouse was lost to redevelopment, but a portion of the façade was restored and incorporated into the Bridgeworks project. The complex presently houses a hotel, restaurants, and shops. Walking Tour Building #2 (GQA-Silke)

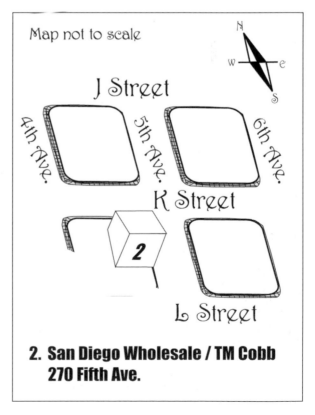

2. San Diego Wholesale / TM Cobb 270 Fifth Ave.

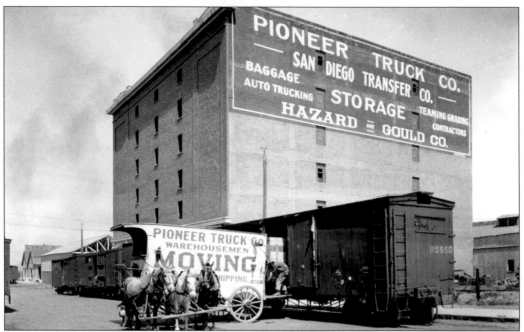

Horses await a load of goods outside Pioneer Truck Company Building, built in 1918. With the pier next door and the San Diego-Arizona and Santa Fe Railroad tracks leading directly to the receiving doors, owners Roscoe Hazard and Elwyn Gould avoided paying extra handling fees. Hazard founded Hazard Construction, which later built many major San Diego freeways. (©SDHS, #1986-A, detail)

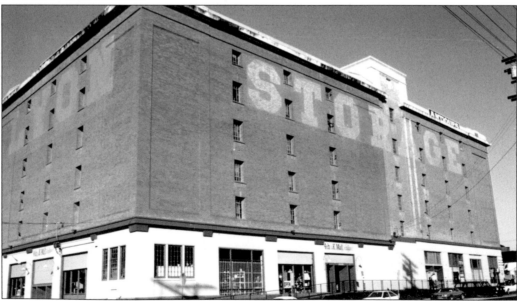

In the 1970s, Fischer Office Interiors occupied the ground floor, but the building became expensive to keep up. Due to its concrete, steel, and brick construction, the building was considered fireproof and a prime candidate for adaptive reuse. It also contained two five-ton freight elevators. Its primary use was always storage; the only difference was that goods were later delivered by semi-trucks. (GQHF)

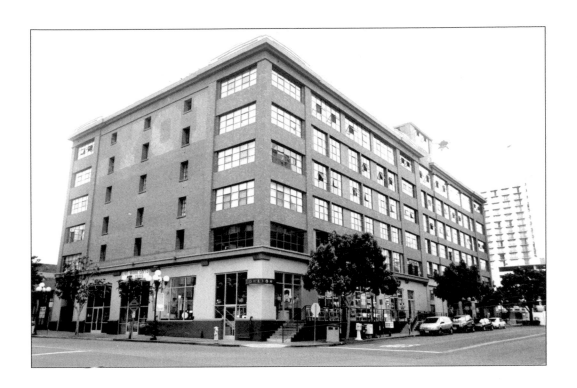

Bud Fischer of Fischer Office Interiors transformed the warehouse into a complex of lofts. When Fischer Office Interiors was sold in 1979, it was San Diego's largest furniture store. The addition of large multi-paned windows expanded the available light inside and enhanced its appeal as a livable space. This creative restoration is a prime example of rehabilitated buildings operating with vibrant residential and retail uses. Walking Tour Building #3 (GQA-Silke)

Map not to scale

Island Ave.

4th Ave. 5th Ave. 6th Ave.

J Street

3

K Street

**3. Pioneer Truck Co
310 Fifth Ave.**

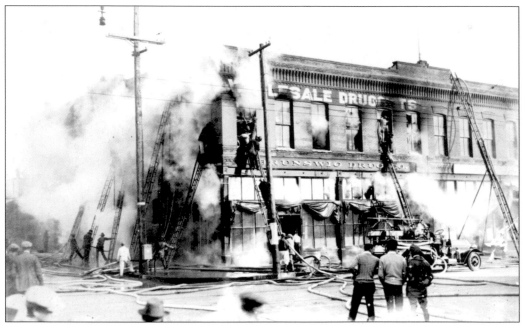

Valiant efforts saved the Brunswig Drug Company Building from total destruction in this fire. Five firefighters were injured, and several others suffered severe lung irritation in this 1915 blaze. Built in 1900 on land acquired for $10,500 in gold, the two-story structure stored medical supplies, including alcohol, which was believed to be the source of the fire. (©SDHS, #3001)

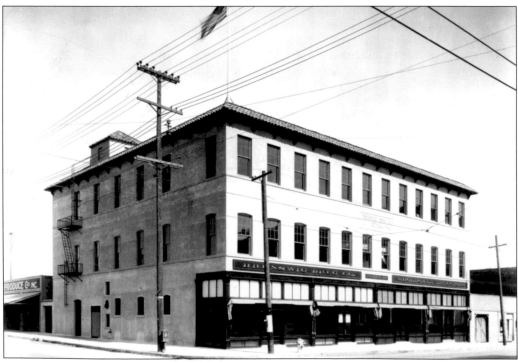

After the fire, the building was repaired and a third story added in 1925. The building, pictured in 1929, continued to operate as a wholesale drug company. (©SDHS, #7764)

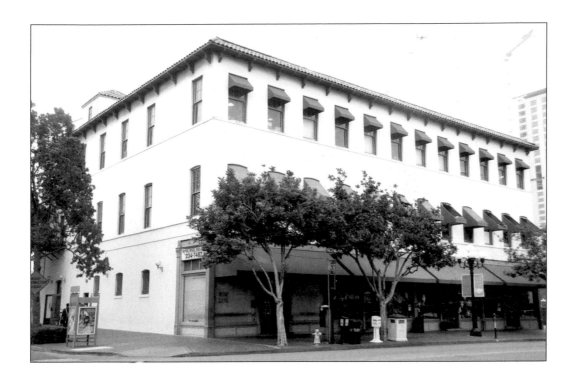

Today, the Brunswig Drug Building has been restored and operates with retail stores on the ground floor and offices above. To assist in the revitalization, owner Mike Farres allowed a mural to be painted on the south side, including one stipulation for artist David Robinson. The mural, which took its inspiration from an 1887 photograph, needed to include his likeness. Robinson complied, and the face of Farres looks down upon visitors as the furthest character on the right. Walking Tour Building #4 (GQA-Silke)

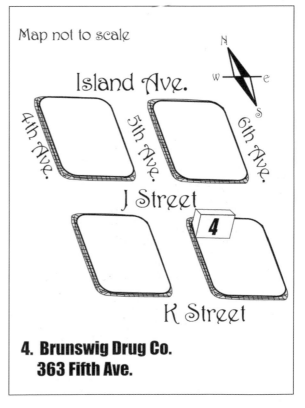

Map not to scale

Island Ave.

4th Ave.

5th Ave.

6th Ave.

J Street

4

K Street

4. Brunswig Drug Co.
363 Fifth Ave.

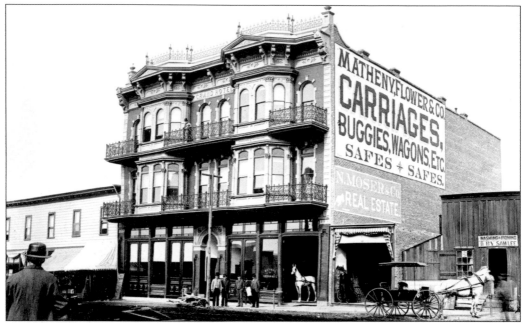

Originally named the Grand Hotel, this three-story, Italianate-Baroque Revival building was erected in 1887 and originally stood at Third Street on what is now the Horton Plaza Shopping Mall parking lot. A truly grand structure, it was designed by architects Comstock and Trotsche as a replica of the Innsbruck Hotel in Vienna. (©SDHS, #931)

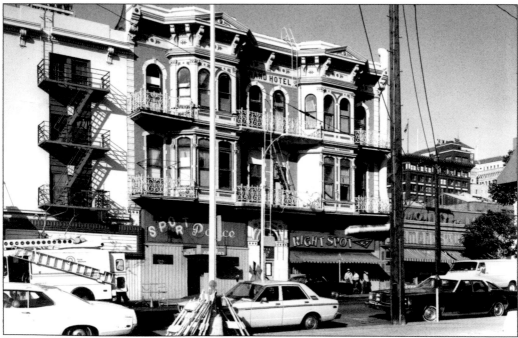

On the fringe of the Stingaree, the Grand Hotel was renamed the Grand Horton when the Horton House hotel closed. By 1981, the Grand Horton had suffered and deteriorated to the point where it was slated for destruction during Gaslamp Quarter revitalization efforts. (©SDHS, #81:9975)

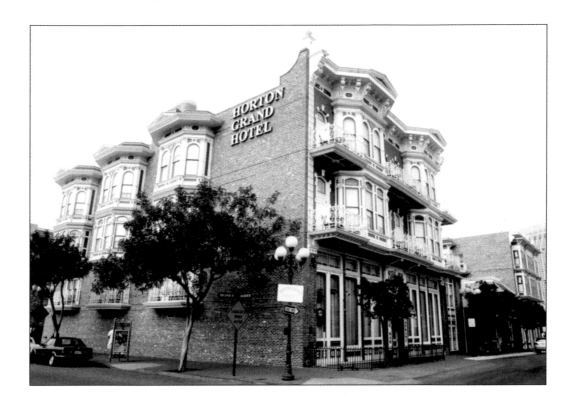

The Grand Horton, once home to famous lawman Wyatt Earp, was saved, sold for $1, dismantled, and reassembled by developer Dan Pearson at its present location on Island Avenue, where it reopened as the Horton Grand Hotel in 1986. An atrium courtyard joins it with the former 1886 Brooklyn Hotel. The Kahle Saddlery was on the ground floor of the Brooklyn. Save Our Heritage Organisation bolstered a group of concerned citizens in the fight to save the two old hotels. In the former Grand Hotel, the original fourth-floor woodwork can be found on the stairwell and is meticulously replicated on lower floors. Inside the former Brooklyn Hotel, a life-size papier-mâché horse stands as a reminder of the saddlery. Joined together, the two hotels form a graceful reminder of early San Diego. Walking Tour Building #5 (GQA-Silke)

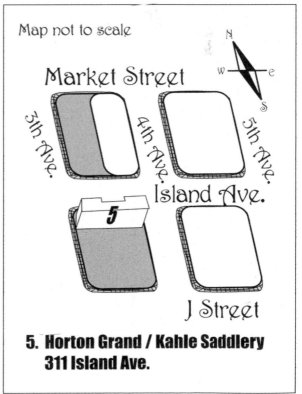

5. Horton Grand / Kahle Saddlery 311 Island Ave.

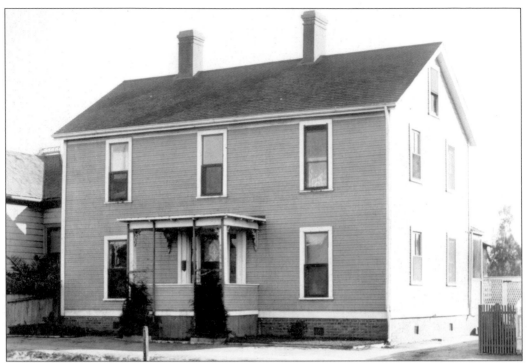

When Alonzo E. Horton arrived in San Diego in 1867, there were just a few of William Heath Davis's pre-fabricated homes remaining in New Town. Horton and his wife Sara Babe lived in this home, which was originally leased to the military by Davis to house officers. Around 1873, the house was moved to Eleventh and K Streets, where it was operated for a time as the county hospital. (©SDHS, #684)

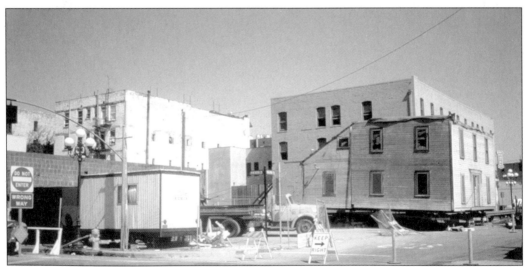

Families lived in this home, without electricity, until 1981, preserving it in their desire that it would someday become a museum. Thanks to their deliberate efforts, it remained structurally unchanged for over 100 years. After the area was designated an historic district, the house was moved to its present location at Fourth and Island Avenues, thanks to the Junior League of San Diego, and named the William Heath Davis House. (GQHF)

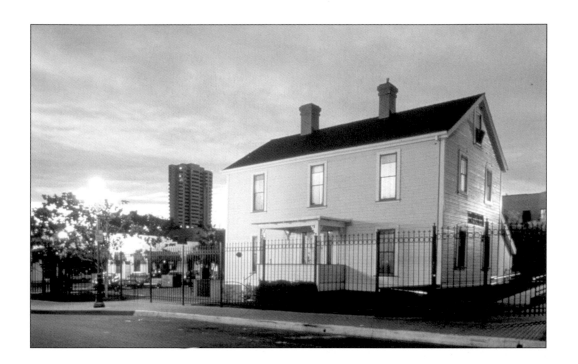

The house, although structurally intact from its original 1850 condition, was in poor shape; the roof needed to be replaced and up to 17 layers of wallpaper removed. The original gas lights were replaced with electric, and curator Mary Joralmon painstakingly restored the interior. She designed each room to represent a specific time period in the over 150-year life of the historic structure, including a military room, Horton's parlor, and a hospital room. The Gaslamp Quarter Historical Foundation operates tours of the house and the Gaslamp Quarter from this location. The William Heath Davis House is now a unique historic house museum, celebrating the lives of the two men who had the vision and the courage to build a city near San Diego Bay, and it serves as a gateway to the historic Gaslamp Quarter. Walking Tour Building #6 (GQHF)

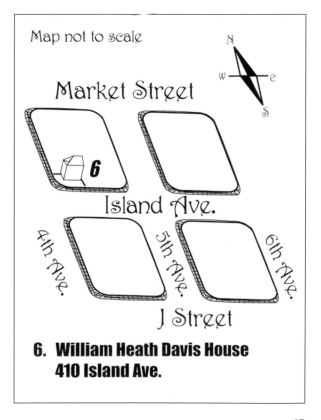

Map not to scale

Market Street

Island Ave.

4th Ave.

5th Ave.

6th Ave.

J Street

**6. William Heath Davis House
410 Island Ave.**

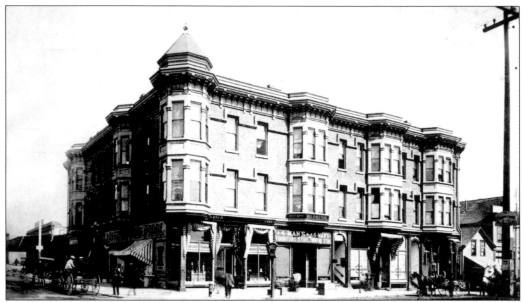

This beautiful Victorian building, constructed in the latter part of the 1800s, housed the Metropolitan hotel. Its uses also included a drug store, furniture store, and various retail establishments. (©SDHS, #13516)

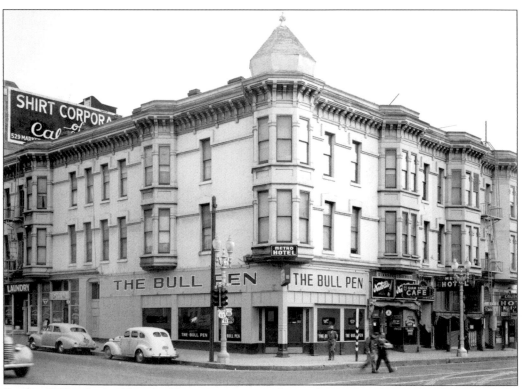

By the 1960s, the building had become quite run down. Owners modernized and removed the exterior Victorian detail work, removing 12 bay windows and adding stucco. This photo was taken in 1950. (©SDHS, #Sensor 5-39)

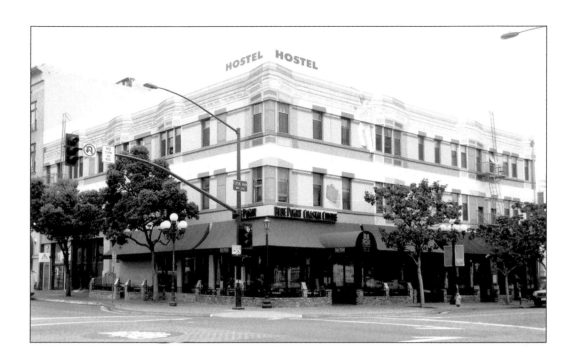

In the 1980s, when there was yet another push to do something about the dilapidated area, city leaders took a second look at Gaslamp historic buildings. The area was designated an historic district, providing tax advantages and incentives to property owners for restoration of designated buildings to their original appearance during their period of historical significance. It was determined by the owners that restoring the Metropolitan Hotel would cost too much money, and so the owner was permitted to paint a trompe l'oeil on the building—a three-dimensional likeness of the historic detailing. Whimsical in approach, it includes a man and his suitcase sneaking out in order to avoid paying his hotel bill. Walking Tour Building #7 (GQA-Silke)

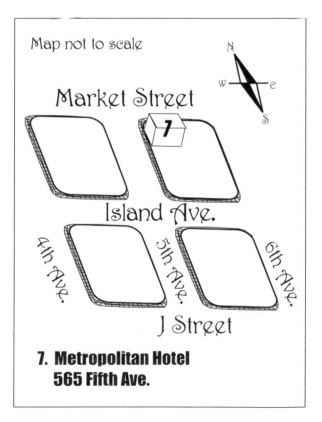

Map not to scale

Market Street

Island Ave.

4th Ave.

5th Ave.

6th Ave.

J Street

**7. Metropolitan Hotel
565 Fifth Ave.**

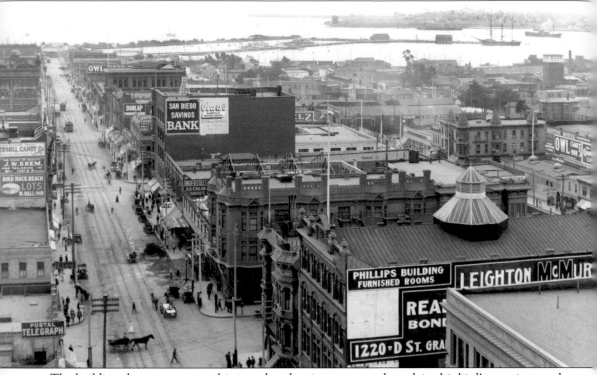

The buildings become more sophisticated as the city grows northward, in this bird's-eye view south on Fifth Street from E Street. Areas near the waterfront fell into neglect as legitimate businesses moved north, leaving the waterfront to its notorious reputation as the "Stingaree." This photo was taken in 1910. (©SDHS, #609)

Three

MIDDLE
GASLAMP QUARTER
Walking Tour Buildings 8–19

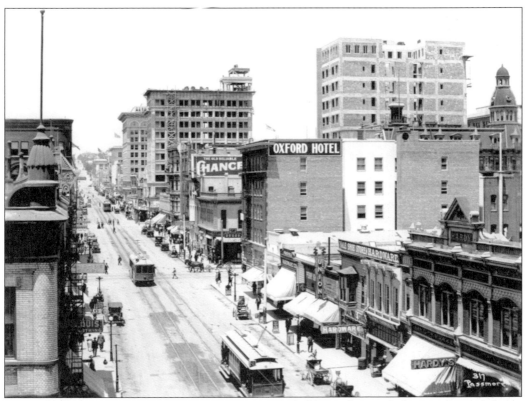

This middle Gaslamp Quarter city scene, *c.* 1912, holds no hints of the successes, failures, dreams, and realities found within. The buildings, and more importantly, the stories of those who built and inhabited them, reveal a glimpse into the struggle to survive, grow and prosper, and build not just buildings and businesses, but a place that would become known as part of America's Finest City. (©SDHS, #4396-2)

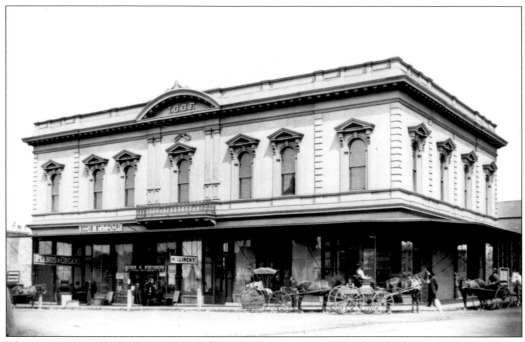

The International Order of Odd Fellows and the Masonic Lodge, both civic organizations, joined together in 1873 to complete the IOOF Building. After nine years, only the excavation of the cellar was complete due to funding problems. Construction resumed in 1882, and a parade was hosted to ceremonially place the cornerstone. Buried with the cornerstone are coins, historical documents, wood from Lebanon, and a stone from Solomon's Temple. This photo was taken c. 1885. (©SDHS, #1400)

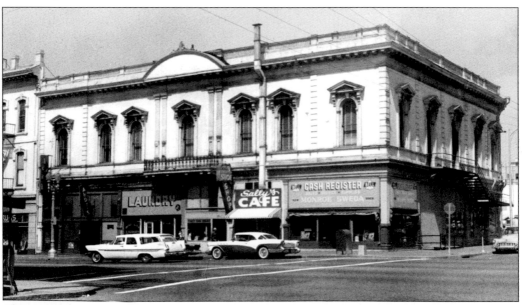

The simple but elegant building has housed several businesses and organizations over the years, including the San Diego Ballet and Save Our Heritage Organisation. Other businesses included Earl's Shoe Repair and Andy's Saloon. This photo was taken c. 1970. (©SDHS, #OP17134-940)

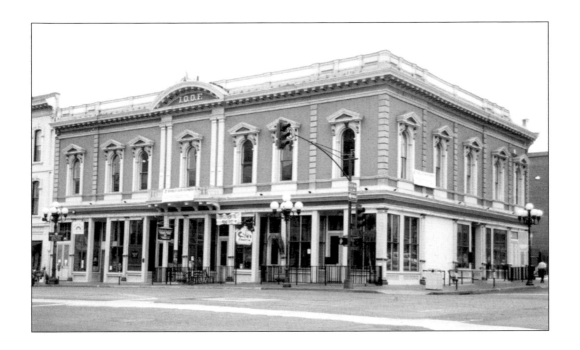

In the 1880s, it was touted that the roof was totally waterproof and fireproof. By the 1950s, the building was cosmetically run down, but otherwise intact. Architect Frank Drake worked on plans to restore the structure in 1980, giving it a fresh coat of paint to highlight the detail work. The large meeting rooms on the second floor used by the civic organizations who commissioned the building can still be seen today. Walking Tour Building #8 (GQA-Silke)

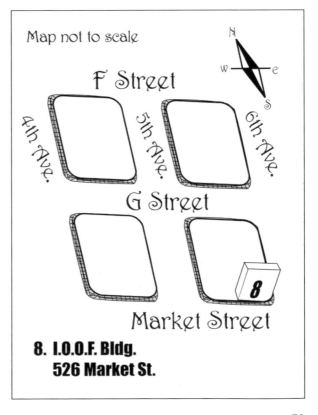

Map not to scale

F Street

4th Ave. 5th Ave. 6th Ave.

G Street

Market Street

8. I.O.O.F. Bldg.
526 Market St.

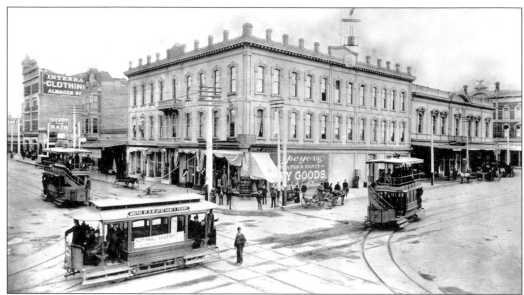

Pictured here in 1895, the McGurck Block, popularly referred to as Ferris & Ferris Drug Store, was first named for Edward McGurck, who owned the building until his death in 1907. His relatives contested his will for several years. Michael McGurck finally prevailed and sold his interest in 1926. The first tenant of the Italianate Revival building was Speyer-Lesem Dry Goods Firm, operating until 1891. (©SDHS, #7783, detail)

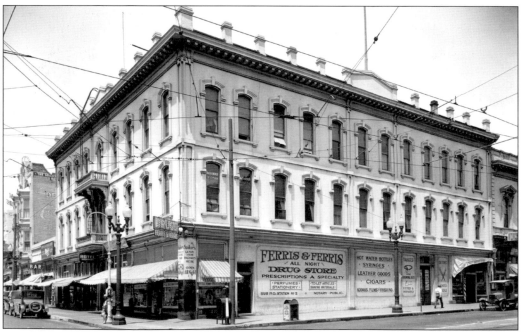

Alda and Claire Ferris of Illinois moved Ferris & Ferris Drug Store to the McGurck Block in 1891. It operated continuously until 1984 as an all-night pharmacy, a necessity for an area frequented by sailors looking for a good time. Many who had been in altercations purchased leeches from the store to reduce swelling and avoid getting in trouble with superior officers. This photo was taken in 1924. (©SDHS, #1921)

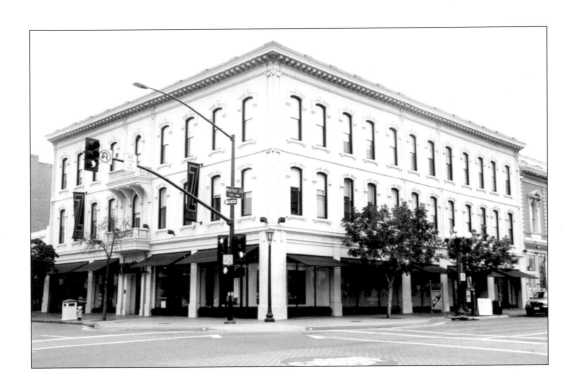

Upon completion in 1887, the McGurck Block consisted of three stories, with a skylight giving light to the second floor. It had 11 chimneys serving as heaters for the rooms. The exterior has been well preserved but the interior received a complete overhaul in the late 1990s. Through the years, the building served as a post office, candy store, and Coronado Ferry ticket booth, and offered rooms for rent above. The most unusual "tenant" of the building was Dr. Gildea's pet Mynah bird, thought to be one of three on the Pacific Coast. Fully restored, the McGurck now houses retail on the ground floor and offices above. Walking Tour Building #9 (GQA-Silke)

Map not to scale

F Street

4th Ave.

5th Ave.

6th Ave.

G Street

9

Market Street

**9. McGurck Block
611 Fifth Ave.**

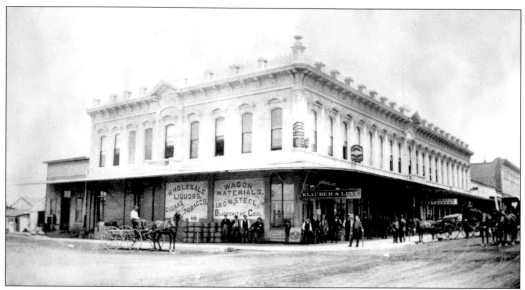

Dr. John Pierce Backesto purchased this property from Alonzo Horton in 1867 for $300 and promptly built a wooden structure on the lot. In 1873, Dr. Backesto began rebuilding the wooden building with brick. After 15 years, the building was completed as it stands today. The Backesto Building was the largest and, perhaps, finest office building of its time in San Diego. This photo was taken in 1888. (©SDHS, #10962)

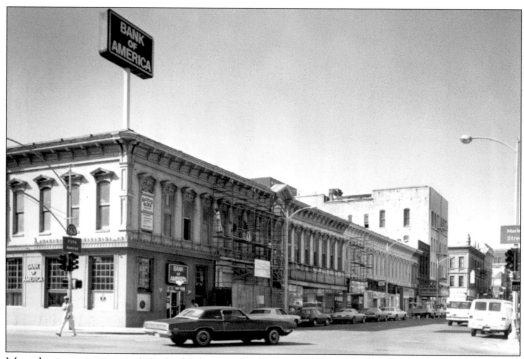

Many businesses occupied the building over the years, including Klauber & Levi grocery store. Fred Gazlay opened his hardware store, San Diego Hardware, here in 1892, eventually moving a few blocks north. Bank of America, which got its start in the Granger Building (964 Fifth Avenue), was a major tenant for several years. This photo was taken in 1980. (©SDHS, #80:2627)

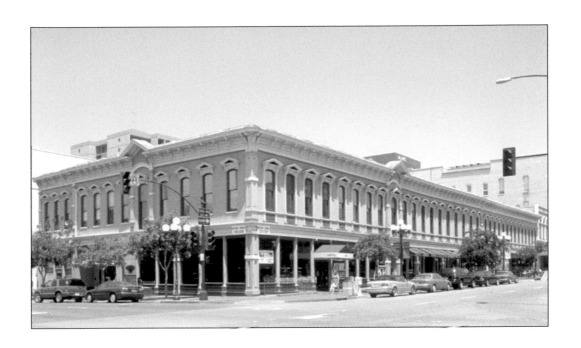

When it was built in 1888, the Backesto was known for its large skylights and "excellent ventilating apparatus." Its estimated cost was approximately $20,000, and it boasted pedimented window columns and interesting cornices. The building encompasses approximately one-quarter of an entire city block. The original detailed roofline overhang, grillwork, and Fifth Avenue balcony have since been removed, but the remaining detail work makes the building appear majestic. One of the first structures to be renovated after the area was designated an historic district, the Backesto Building has been beautifully restored. It is now home to restaurants and retailers on the ground floor and contains professional offices above. Walking Tour Building #10 (Courtesy John Durant, Photographer).

Map not to scale

F Street

4th Ave. 5th Ave. 6th Ave.

G Street

10

Market Street

10. Backesto Bldg.
617 Fifth Ave.

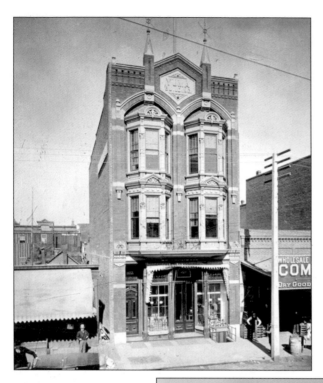

Alfred Henry Wilcox arrived in San Diego in 1849 as captain of a ship carrying a government crew charged with turning the San Diego River into "False Bay" (Mission Bay). He became involved in Colorado River steam boating, publishing, and banking, and commissioned this Italianate-Baroque Revival building from Armitage and Wilson Architects in 1888. The Yuma Building was most likely named for his experiences near Yuma, Arizona. This photo was taken in 1889. (©SDHS, #198)

Interior designer Marsha Sewell-Shea recognized the beauty of this structure, pictured here in 1980, as it sat amidst a sea of pornographic movie houses in the 1980s. She purchased it as a residence for herself and her architect husband, Michael Shea. The Sewell-Sheas were among the first, during revitalization, to recognize the potential of the Gaslamp Quarter as a great place to live. (©SDHS, #80:2753, detail)

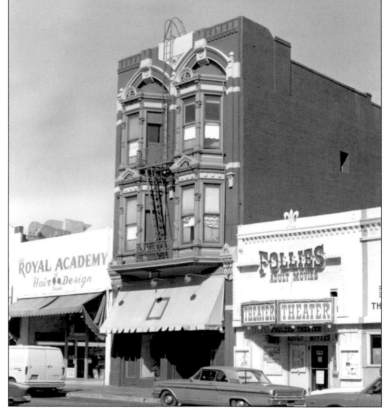

The Yuma Building became a brothel during the Stingaree era. At an unknown point in history, the decorative spires and roof of the structure had been removed. The Sewell-Sheas used historic photographs to restore the roofline to its original 1888 appearance and completely gutted and restored the interior, removing walls to take advantage of the large skylight that allows natural light to pour in. After restoration, the Yuma Building gleams, yet will forever be remembered as the first business closed down during the Stingaree raid of 1912. Walking Tour Building #11 (Courtesy John Durant, Photographer)

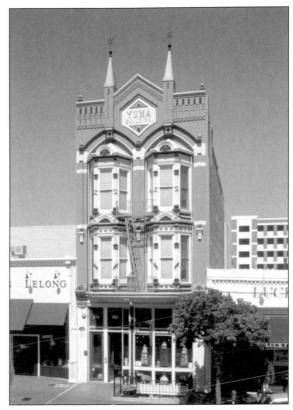

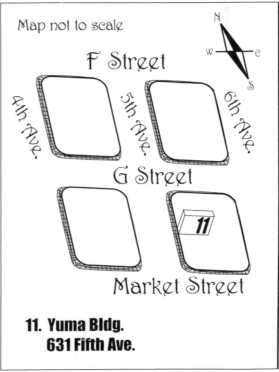

Map not to scale

F Street

4th Ave. 5th Ave. 6th Ave.

G Street

Market Street

11. Yuma Bldg.
631 Fifth Ave.

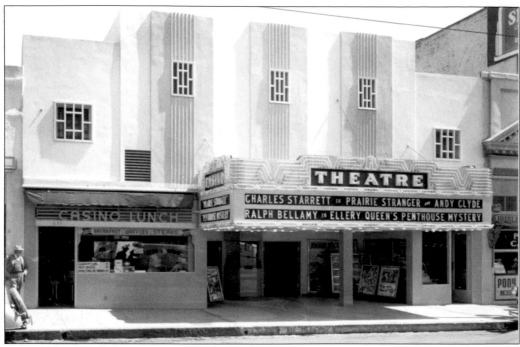

George Chambers, father of famed Olympic swimmer Florence Chambers, acquired the future Casino Theatre site in 1904 but didn't build on it until 1912. When he did, the building was the first theatre in San Diego to meet new fire safety ordinances. Five-foot-wide walkways on both sides of the entrance provided safe fire exits. Two years later however, the passages accommodated a restaurant and shoeshine stand. This photo was taken in the 1920s. (©SDHS, #Sensor 7-130)

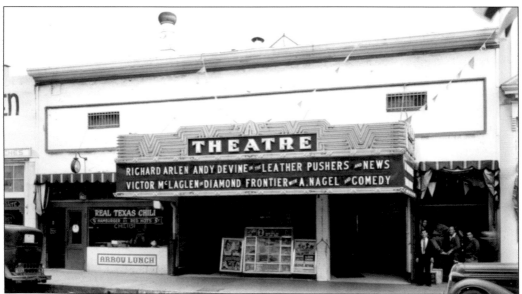

The building continued as a theatre for many years, though the proprietors changed often. The Russo family operated it from 1922 through 1956. When the area south of G Street became home to liquor stores, bars, adult bookstores, and X-rated movie houses, the Casino Theatre catered to clientele frequenting the run-down area. (©SDHS, #7-131)

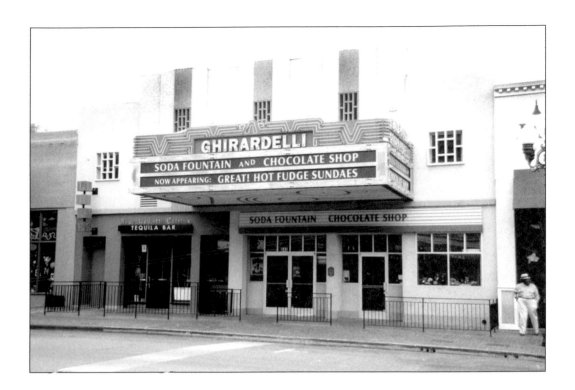

As the area began to be restored and investors began looking for new uses for old buildings, theatres posed interesting challenges. Able to accommodate only one or two screens at a time when multiplexes were the norm, theatre buildings were not as cost-effective to operate as movie houses and began to be renovated for other uses. When redevelopers expressed interest in the Casino Theatre, the original plans called for the repair of the old marquee. The contractor determined that the sign was too badly damaged and created this larger scale, but well-executed replica. Walking Tour Building #12 (GQA-Silke)

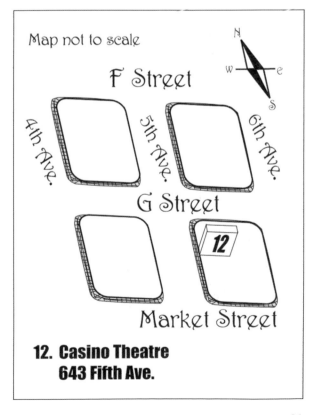

Map not to scale

F Street

4th Ave.

5th Ave.

6th Ave.

G Street

12

Market Street

12. Casino Theatre
643 Fifth Ave.

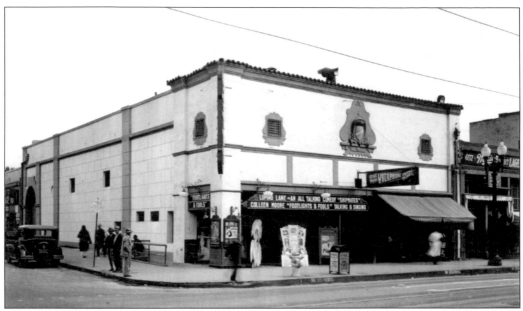

Hubert Howe Bancroft devoted much of his life to the study of California's history. He arrived here in 1869, purchased land, and began gathering material regarding the Missions and San Diego history. His plan was to build on this lot an exact copy of his Bancroft History Building in San Francisco. The history building never came to pass; instead, he built the Bancroft Building in 1886. This photo was taken in 1930. (©SDHS, #Sensor 7-73)

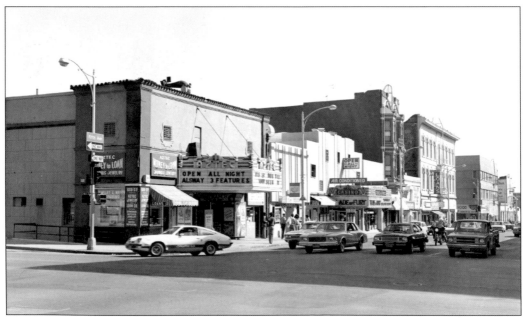

In 1910, the building became a movie theater, named Jewell Theatre. It became the Aztec in 1930 and advertised an "all talking comedy." During the decline of the 1960s and 1970s, the Aztec became an X-rated movie house, a major change from its stringent 1904 lease, in which Bancroft stated, "there be no disreputable or objectionable persons on premises, with no prostitution or women of known unchastity." This photo was taken in 1980. (©SDHS, #80:2748)

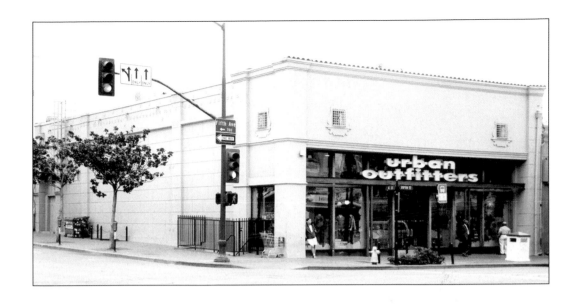

The building's facade first included decorative details hiding unsightly vents. When the marquee was built, many decorative details were removed or painted over, having the unfortunate effect of weakening its appearance. While only traces of the original structure peek through, it is appropriate that this building be acknowledged, standing as a reminder of the importance of preserving history—something akin to what Bancroft first envisioned. Walking Tour Building #13 (GQA-Silke)

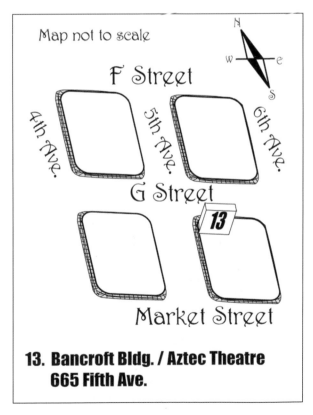

13. Bancroft Bldg. / Aztec Theatre 665 Fifth Ave.

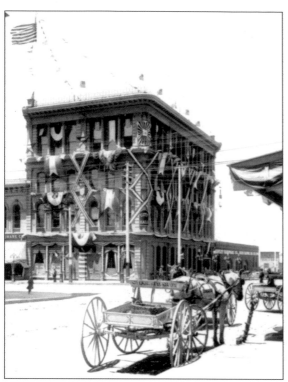

Consolidated National Bank was housed in the two-story Old City Hall in 1874. It was Florentine-Italianate revival in style and was the first building to be constructed entirely of materials from San Diego. The first floor housed the bank, while a library with bookcases for 8,000 volumes occupied the second floor. After two stories were added, the San Diego Public Library moved into the fourth floor. In 1891, government offices took over the building. This photo was taken in 1901. (©SDHS, #22466)

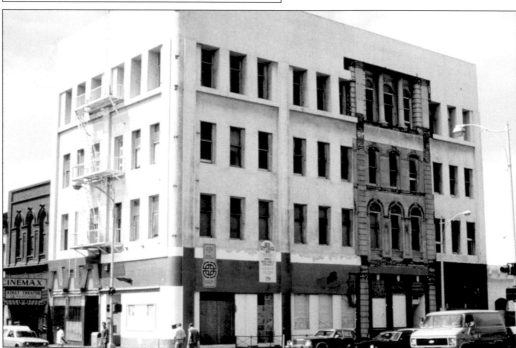

In the 1950s, there was an effort to clean up and modernize the area. Many buildings thought to be "old fashioned" were modernized with stucco. This beautiful building's Florentine-Italianate grace and elegance were hidden. Notice restoration efforts uncovering layers of stucco to the right in this 1980 photo. (GQHF)

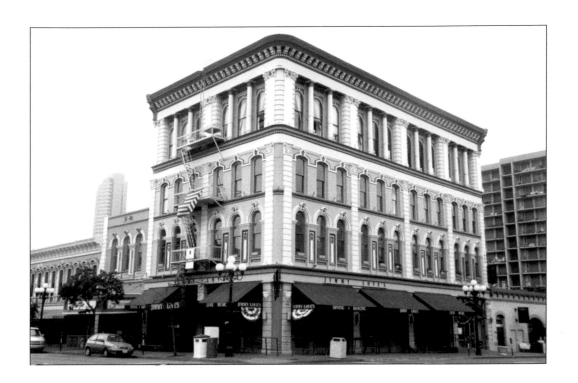

In the 1980s, after the area was successfully designated an historic district, money became available to investors, who purchased historic Gaslamp buildings and began the arduous process of restoring them to their original glory. The beautifully restored Old City Hall is a shining example of how returning to the past can ensure the future of a dilapidated area. Walking Tour Building #14 (GQA-Silke)

Map not to scale

F Street

4th Ave.

5th Ave.

6th Ave.

G Street

14

Market Street

**14. Old City Hall Bldg.
664 Fifth Ave.**

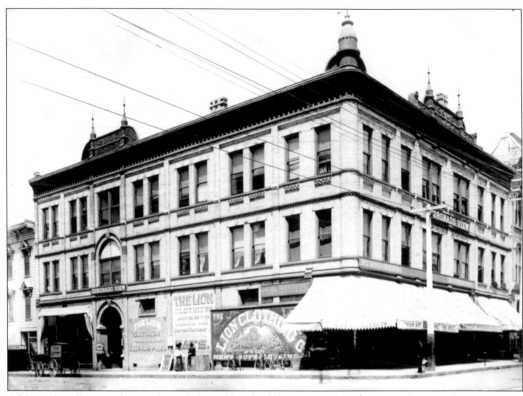

Although Albert Cole purchased the Cole Block lot in 1873 for $900, architect John Stannard designed the present building in 1892. Theophile Verlaque, instrumental in developing San Diego's winemaking industry, occupied the site's first building. Verlaque also founded the town of Ramona. Unfortunately, Cole suffered legal difficulties and poor health, and he committed suicide as the building was under construction. This photo was taken in 1890. (©SDHS, #813)

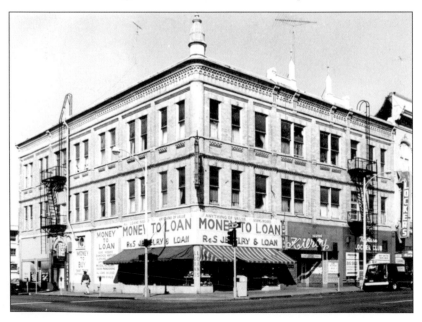

Cream-colored bricks set in red mortar and granite keystones in the arches were elements of architect John B. Stannard's building design. The Cole Block became the Welcome Hotel, then the New Kelsey Hotel until the 1980s. This photo was taken c. 1971. (©SDHS, #OP 17134-934, detail)

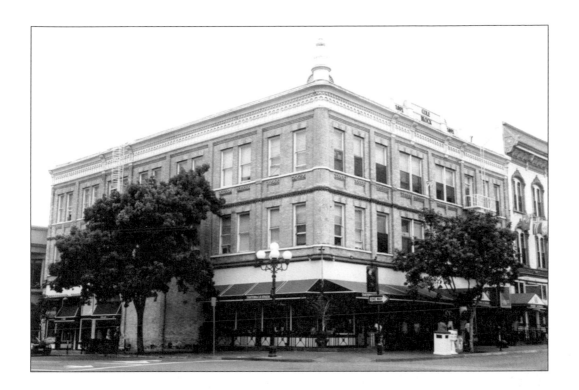

After redevelopment and the removal of extensive signage, the building's attractiveness returned, adding warmth and appeal to the restaurants on the ground floor and apartments for rent above. Ralph Granger of Gaslamp's Granger Building held an interest in the structure for a time. He founded a music conservatory in Paradise Valley and possessed a fine collection of rare violins. One of the original tenants was a grocer who advertised "imported" goods from San Francisco. Other tenants included Andrew Dumas' Soft Drinks-Confectionery (1911–1930), the Owl Loan Company (1927–1928), and People's Fish Market (1924). Upper floors housed the Coronado View Hotel from 1895 to 1925. Walking Tour Building #15 (GQA-Silke)

15. Cole Block Bldg.
702 Fifth Ave.

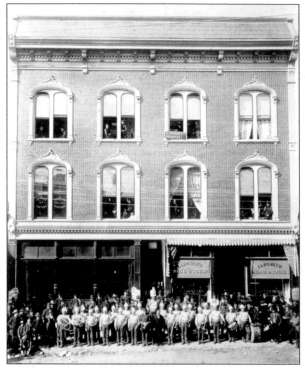

When David Llewelyn died in 1886, he left a rather unusual will. His fortune was left to his daughter Hannah Elizabeth Allen. His son William received $10. William ran a successful brick kiln, however, and in the 1870s and 1880s made bricks for many of the buildings in the Gaslamp. William built the Llewelyn Building in 1887 and operated Llewelyn Shoe Store until 1906. This photo was taken in the 1880s. (©SDHS, #6635)

Anker's Pendleton Western Wear founded their store in the Llewelyn Building in 1906. The Anker family closed the store in 1973, and the ground floor became adult theatres. This photo was taken in the 1980s. (©SDHS, #80:2562)

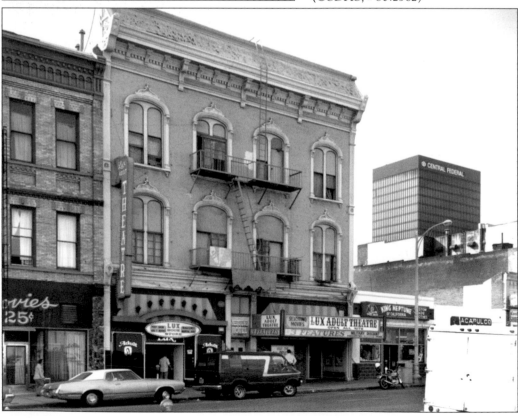

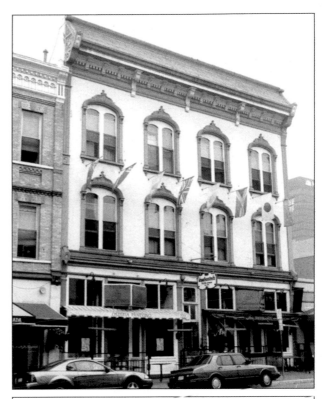

Several hotels with poor reputations have used the building over the years. In 1906 it became the Dunlap House. The names changed several times over the years, and each had an unsavory reputation. In 1917, charges were brought against the Louis House proprietor Mrs. Ollie Thomas for operating a "cat house" in the structure. Ultimately, 1981 preservation efforts resulted in the Llewelyn Building's beautiful restoration. Its delicate arched windows, detailed moldings, and cornices give it the appearance of a grand lady in an historic district. Walking Tour Building #16 (GQA-Silke)

Map not to scale

F Street

4th Ave. 16 5th Ave. 6th Ave.

G Street

Market Street

**16. Llewelyn Bldg.
722 Fifth Ave.**

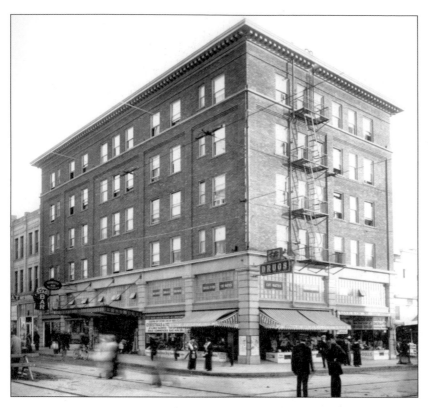

Professionals occupied the Young Block building, originally on this lot, including Edwin Capps, a real estate agent who became mayor in 1899. Another tenant, Mrs. E. Turner, the owner of Elite Photographic Studio, offered, according to a newspaper, "incentive to other women to engage in new lines of business." (©SDHS, #5703, detail)

The Young Block building was torn down in 1912, and Pennsylvania native Levis Brinton erected the six-story Oxford Hotel in its place. It was advertised as "the only first-class hotel in the hub of [the] amusement and shopping district." Eagle Drug Company was the only tenant to occupy all floors. The William Penn Hotel eventually took over the top floors. This photo was taken in 1980. (©SDHS, #80:2742, detail)

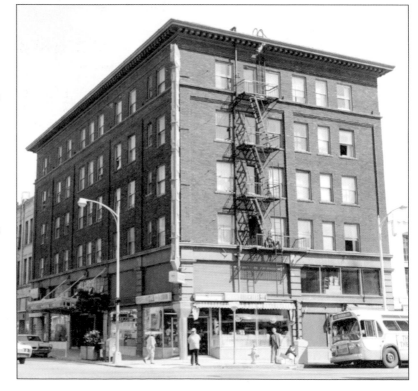

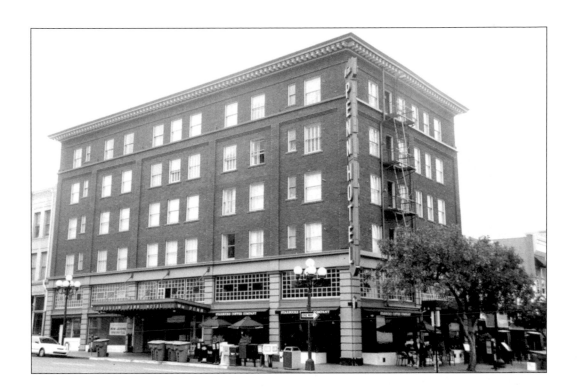

One of the newer structures in the historic district, this building has undergone considerable changes to the ground floor storefronts over the years. The original glasswork surrounding the building was restored recently. Walking Tour Building #17 (GQA-Silke)

Map not to scale

F Street

4th Ave.

5th Ave.

6th Ave.

17

G Street

Market Street

**17. Oxford Hotel//William Penn
509 F Street**

One of the oldest structures still standing in the Gaslamp Quarter, the 1874 Spencer Ogden Building (right) was initially one story. The building got its name when business partners Spencer and Ogden purchased it in 1881. A second story was added in 1885. In 1887, an explosion occurred when turpentine accidentally spilled on sulfur while making firecrackers, but was extinguished before major structural damage occurred. (©SDHS, #3250-1)

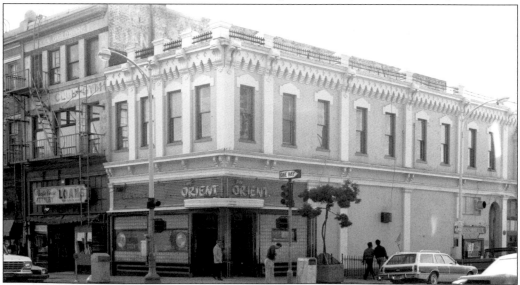

Throughout the early 1900s, the second floor was home to dentists' offices. One dentist was part of the famous "Painless Parker" chain dentistry offices. Edgar R.R. Parker owned the chain and developed the "painless" method. He legally changed his name to "Painless" to avoid trouble from the state dental association. Restaurants occupied the lower level of the structure for many years, including the Orient, shown here in 1980. (©SDHS, #80:2564)

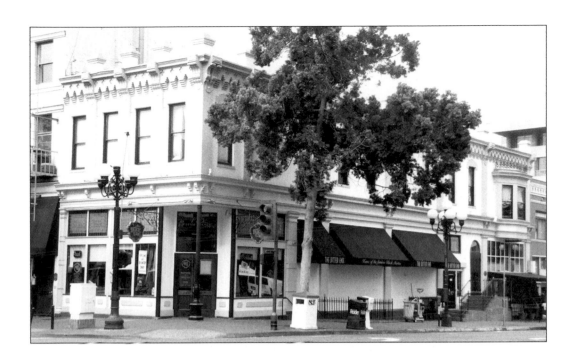

Ornamental grillwork was removed from the roof and parapet during the 1930s due to earthquake ordinances. In the 1940s, the metal grillwork was donated to the U.S. government for the World War II war effort. Apart from this, the building's exterior has not changed much in almost 120 years. Walking Tour Building #18 (GQA-Silke)

Map not to scale

F Street

18

4th Ave.

5th Ave.

6th Ave.

G Street

Market Street

18. Spencer Ogden Bldg.
750 Fifth Ave.

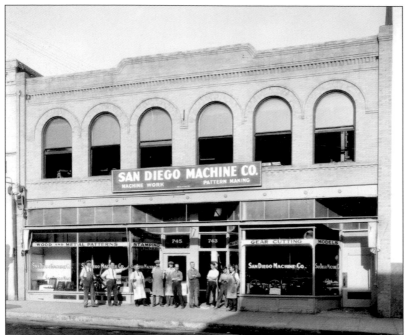

The Labor Temple Building, built in 1907 and seen here in 1921, was a gathering place for unions, including bartenders, cigar makers, theatrical employees, and women's leagues. From 1920 to 1924, the San Diego Machine Shop, operated by Charles Kessler, occupied the site. Kessler also operated the Arts and Crafts Press. (©SDHS, #8908, detail)

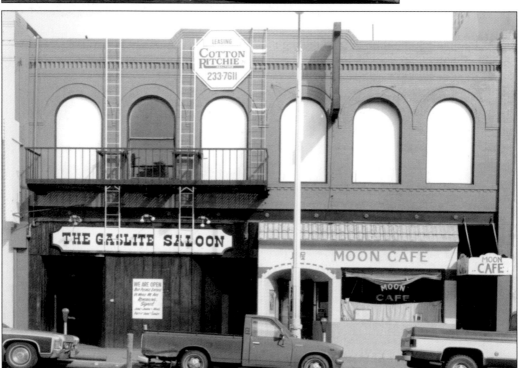

After the machine company closed, the building had many uses, including a paint business, a chemical company, offices for Volunteers of America, and San Diego County health offices. On the ground floor, a saloon used a name similar to the Gaslamp Quarter moniker. The Moon Café is still in operation but located further south in the 700 block of Fourth Avenue. This photo was taken in 1980. (©SDHS, #80:2558)

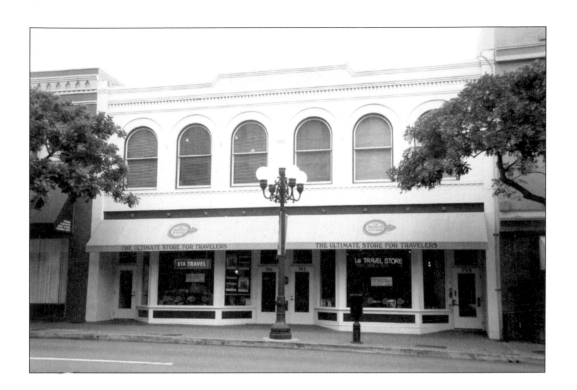

Much of the building's original facade was obstructed by signage and fixtures in the 1970s. Restoration included the removal of the boarded-up windows and the balcony, returning the storefront to its early appearance. The original 1907 interior ceiling and joists can still be seen inside the ground floor retail establishment. Walking Tour Building #19 (GQA-Silke)

Map not to scale

F Street

4th Ave.

5th Ave.

6th Ave.

19

G Street

Market Street

19. Labor Temple Bldg.
 743 Fourth Ave.

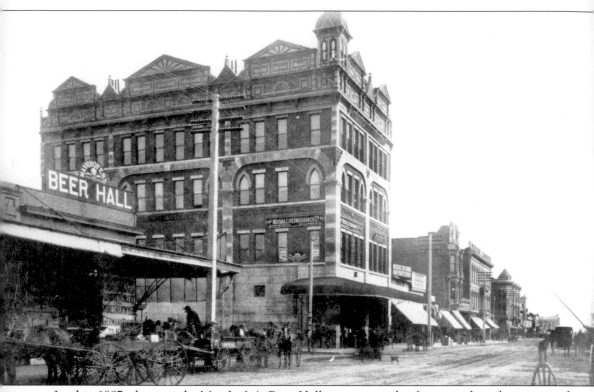

In this 1887 photograph, Mayrhofer's Beer Hall appears in the foreground at the corner of Fifth and G Streets, dwarfed by the opulent architecture of what is thought to be the original Bancroft Building. The Bancroft Building was reduced to two stories and became a movie house sometime around 1919. The Bancroft Building is #13 on the walking tour. See pages 82 and 83. (©SDHS, #3286)

Four

NORTHERN
GASLAMP QUARTER
Walking Tour Buildings 20–30

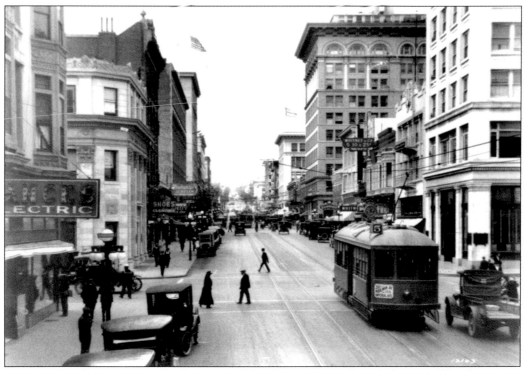

Northern Gaslamp Quarter is characterized by the unexpected, including a golden lion, iron eagles, and zoo specimens. This area saw the success of J. Jessop & Sons Jewelers and the struggles of Woolworth & Company. San Diego Hardware's long-term survival is particularly remarkable. In this 1923 view, downtown San Diego prospers before the stock market crash of 1929 and World War II. Looking north on Fifth Street from F, the remodeled First National Bank Building is visible on the left, while the Watts Robinson Building, a "skyscraper" by 1923 San Diego standards, stands over Fifth Street. (©SDHS, #9167)

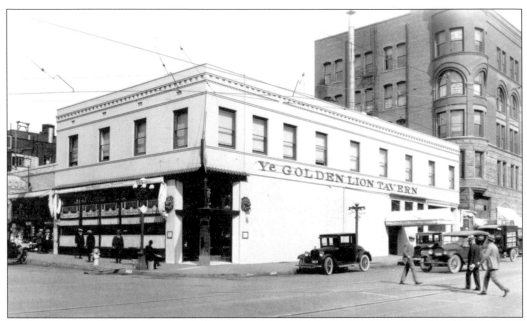

Although the land was acquired for $1,000 in 1878, the Ingle Building was not built until 1906. It was named after the owner's son-in-law, J.J. Ingle, a promising young lawyer and one-time deputy city attorney. In 1907, Ye Golden Lion Tavern men's buffet opened on the ground floor and became known as one of the best restaurants in the West. (©SDHS, #7573)

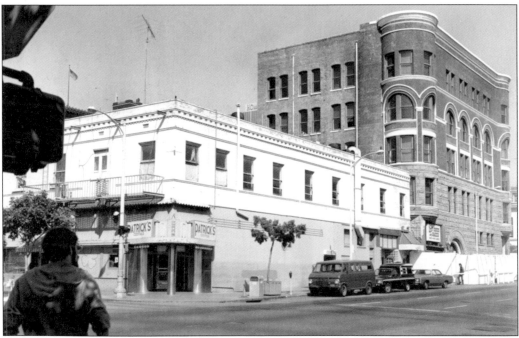

A change of ownership in 1915 resulted in the demise of the men's club, and ladies were allowed to enter. In 1932, the Golden Lion moved to two other locations before closing its doors in 1965. It opened again in the Gaslamp for a brief stint in the 1980s, housing many memories for old time San Diegans. (©SDHS, #80:2735)

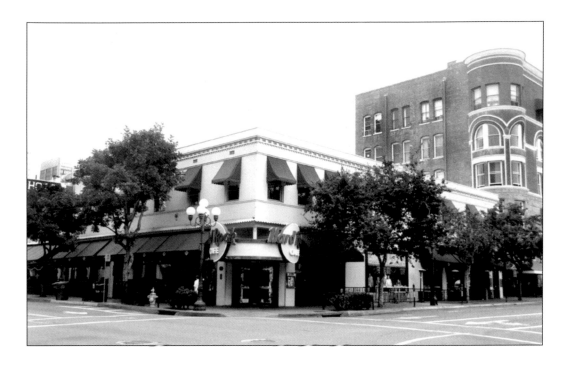

Today, a golden lion statue (originally located above the entry) stands guard and beautiful stained-glass windows overlook Fourth Avenue. Inside, a marvelous stained-glass dome shipped from an Elks Lodge in Stockton, California, bathes the interior in multicolored light. Stained-glass and architectural details were added after the structure was partially destroyed by fire in 1980. Fine wood panels grace the Fourth Avenue side of the building, referencing the men's club once housed inside. A restaurant now occupies the ground floor, with offices above. Walking Tour Building #20 (GQA-Silke)

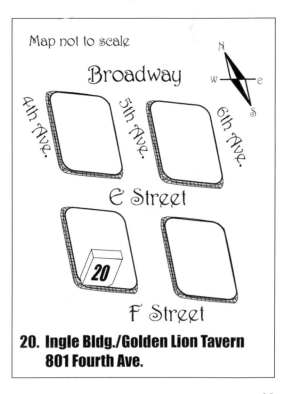

**20. Ingle Bldg./Golden Lion Tavern
801 Fourth Ave.**

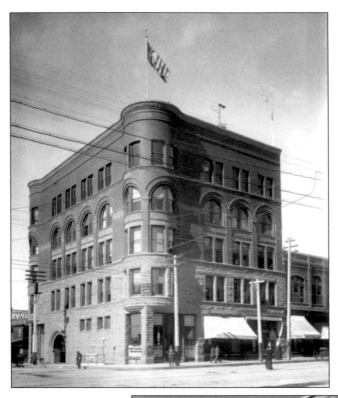

Nicknamed the "marriage building," the Keating Building was financed for $135,000 in 1890 by George Keating of Smith & Keating farming equipment. Unfortunately, George died, and wife Fannie finished the building, changing some design elements to expedite construction. With conveniences such as steam heat and an iron cage elevator, it was one of the area's most prestigious and innovative office buildings. (©SDHS, #23508)

The ground floor of the Keating housed San Diego Savings Bank, the Public Library, and San Diego Humane Society. Tenants included attorneys, doctors, dentists, photographers, and architects. The basement held a locker club for sailors to change and shower. Attached to the exterior was a key shop, operated for over 68 years by the much beloved and trusted locksmith Armond Viora. (©SDHS, #OP 17134-936, detail)

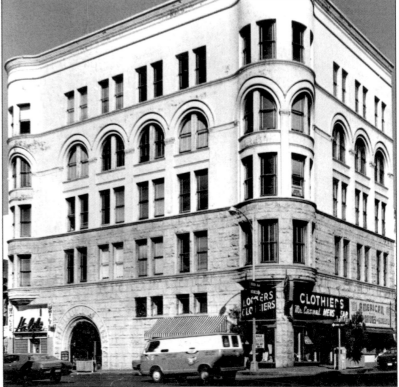

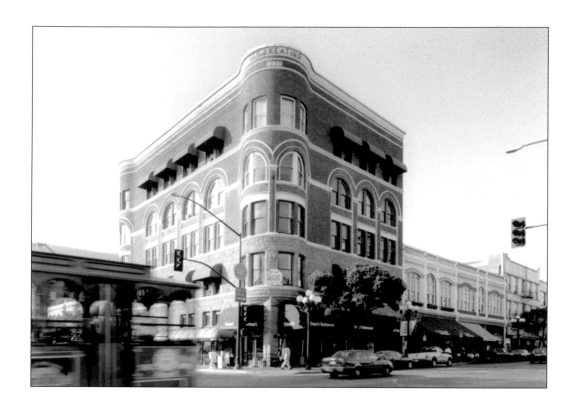

Modern Gaslamp pioneer Ingrid Croce saw potential in the Keating while strolling through the Gaslamp Quarter with her husband, singer/songwriter Jim Croce. After his untimely death, she opened Croce's, a restaurant and jazz club, bringing new life to the area. The upper floors are still offices, where one can find original brass doorknobs and plates; outside, embedded in the curb, are iron rings for tying horse reins. The heavy stonework has protected the building from undergoing too many exterior changes apart from a variety of signage and awnings. The top three stories of delicate red brick were painted at one point, perhaps to lighten up the appearance, but had the effect of emphasizing the heaviness of the stone below. The unique combined gas and electric interior fixtures were converted to standard electric in 1947. Walking Tour Building #21 (©Travers-SDHS-2000/100.34)

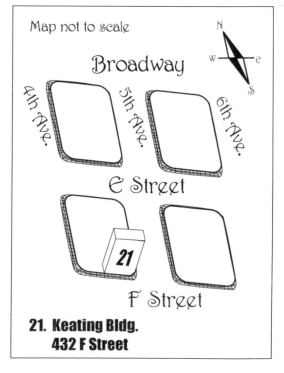

Map not to scale

Broadway

4th Ave.

5th Ave.

6th Ave.

E Street

21

F Street

21. Keating Bldg.
432 F Street

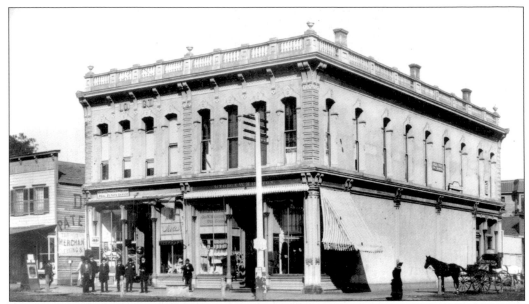

This Victorian-Italian-style structure was built as the second of three locations for Marston's Department Store. Upon his arrival in San Diego, George Marston took a job as clerk and bookkeeper for Alonzo Horton's Horton House hotel, later finding a partner to start a grocery and dry goods store. That partnership ended, but George opened Marston's, which earned the reputation as San Diego's finest dry goods store. (©SDHS, #80:1245)

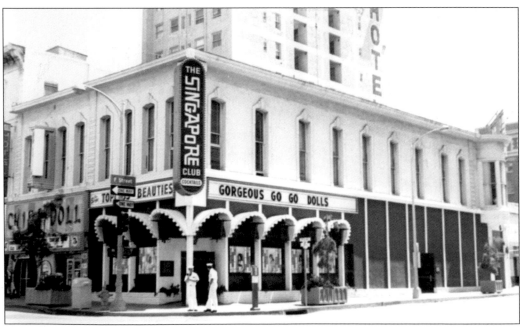

In 1887, George Marston paid an $18 deposit for the installation of a 125-foot electric arc tower to be installed on this corner in front of his store. The store operated here until 1896, then moved to a larger building. Marston ran for mayor in 1913 and in 1917, losing because he favored city planning and beauty over growth. When Marston's moved out of this building, adult-oriented businesses moved in. (©SDHS, #OP 17134-944)

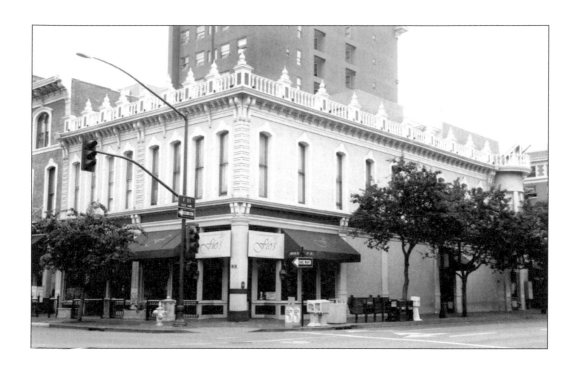

Restored to its earlier splendor and housing high-quality restaurants, the Marston Building is an important reminder of the extensive civic contributions of George Marston, including the development of San Diego's YMCA, Balboa Park, Torrey Pines, Anza-Borrego State Park, the Serra Museum, and San Diego Historical Society. Marston's moved north to D Street (Broadway), and a seedier element slowly moved into the Gaslamp, contending with the classic Italianate-Victorian architectural style designed by the Stewart Brothers in 1881. After restoration, the extensive finish work crowning the building was replaced. Walking Tour Building #22 (GQA-Silke)

Map not to scale

Broadway

4th Ave. 5th Ave. 6th Ave.

E Street

F Street

22

**22. Marston Bldg.
809 Fifth Ave.**

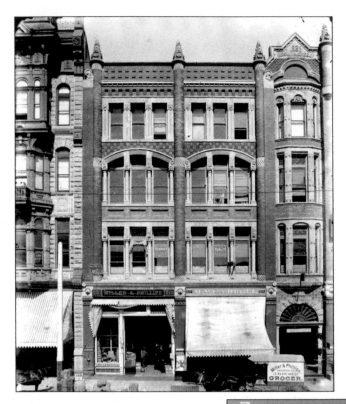

Alonzo Horton deeded the lot for the future Romanesque Revival–style Nesmith-Greeley building to Henrietta Nesmith for $1,900 in 1873. Her father, Thomas Nesmith, likely brokered the deal. He was president of the Bank of San Diego and the Citizen's Committee of 40, a group organized to bring railways to San Diego. Before the building's construction, the lot housed San Diego's first bookstore—J.C. Packard's. This photo was taken *c.* 1895. (©SDHS, #21566)

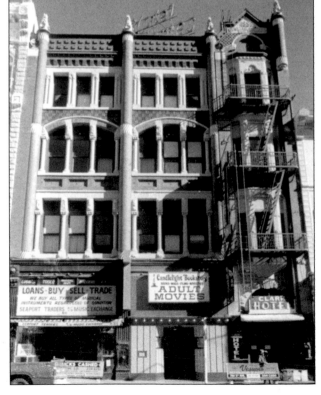

Lt. Adolphus Washington Greeley, Henrietta's husband, led an ill-fated 1881 Army polar expedition. When this 25-man expedition was lost, Henrietta insisted a bounty be imposed, which ultimately resulted in their rescue. When found in 1884, only six of the party had survived, and though her husband was awarded a Congressional Medal of Honor for his leadership, Henrietta was responsible for continuing the search for the group. This photo was taken *c.* 1980. (GQHF)

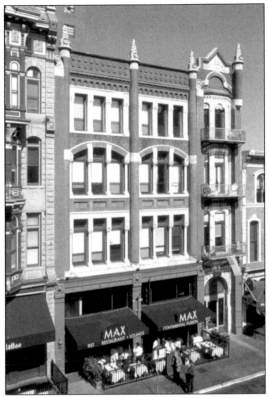

The Romanesque Revival Nesmith-Greeley building departs from the usual style of architects Comstock & Trotsche, known for their Victorian Old City Hall, Pierce-Morse, Grand Hotel, and Villa Montezuma. No major exterior changes or deterioration are of note, validating Nesmith's intention to build a structure of enduring character. He succeeded spectacularly in this fitting tribute to his remarkable daughter and her heroic husband. The building now houses mixed-use office, residential, and retail space. Walking Tour Building #23 (Courtesy John Durant, Photographer)

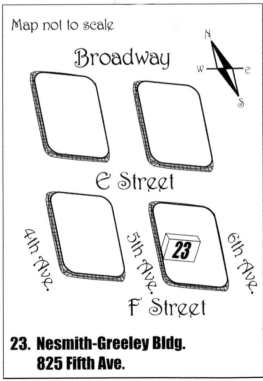

Map not to scale

Broadway

E Street

F Street

4th Ave.

5th Ave.

6th Ave.

23

23. Nesmith-Greeley Bldg.
825 Fifth Ave.

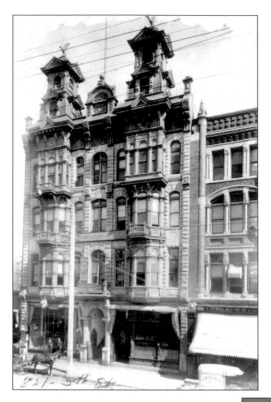

From cobbler to capitalist, Prussian immigrant Isidor Louis arrived in San Diego in 1870 and made French-style shoes for San Diego's elite. He built the Louis Bank of Commerce Building, housing a state bank specializing in business loans. From the building, Louis also operated the Maison Doree, San Diego's first ice cream parlor, and an oyster bar frequented by Josie and Wyatt Earp. This photo was taken in 1890. (©SDHS, #3329)

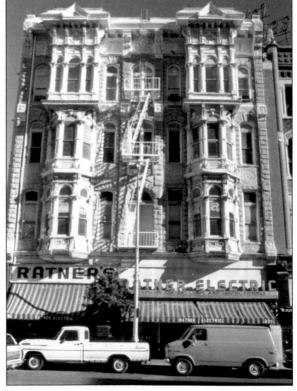

A barber named Isidor Lewis opened a shop next door and caused much confusion about who owned the building, which also had booksellers and jewelers as tenants. During the time it housed Ratner Electric, it earned the nickname "house of a thousand lights." This photo was taken *c.* 1980. (GQHF)

During construction of the Louis Bank of Commerce in 1888, wood only arrived for three of four planned balconies. After 1900, the upper floors of the building contained the Golden Poppy Hotel, which competed with Ida Bailey's Canary Cottage for the title of finest brothel. Madam Corara dressed her ladies in colors matching the doors of their rooms and "advertised" by strolling the streets. In the early 1900s, three balconies were removed, a 1904 fire destroyed the towers, and the iron eagles topping them disappeared. When preservation began, only three balconies were built, making the restoration true to is its "unbalanced" 1888 appearance. Designed by architects Clemment and Stannard, the Baroque Revival, four-story building now includes replacement twin iron eagles. Restaurants, a club, and offices now occupy this building. Walking Tour Building #24 (Courtesy John Durant, Photographer)

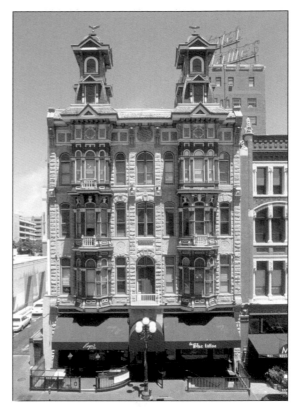

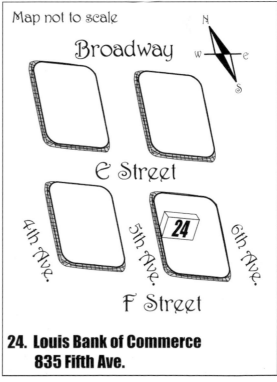

Map not to scale

Broadway

E Street

4th Ave.

5th Ave.

24

6th Ave.

F Street

24. Louis Bank of Commerce
835 Fifth Ave.

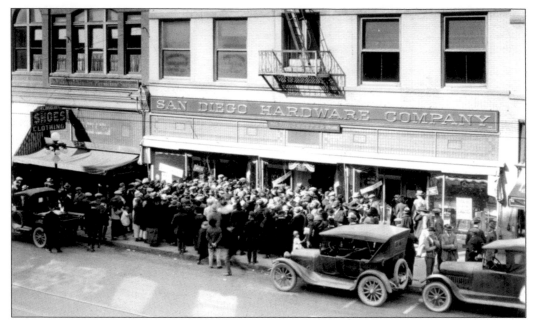

Captain Dunnells purchased this lot from Alonzo Horton in 1868 and constructed a Victorian-style structure on it. In 1907, two businesses shared the site, Charleston and Company and Woolworth Company. The present building was constructed in 1910 and included a Knights of Columbus Hall, a dance hall, and Woolworth "Five and Dime." This photo was taken in 1922, during the opening day celebration for San Diego Hardware's second location. (©SDHS, #2015-A, detail)

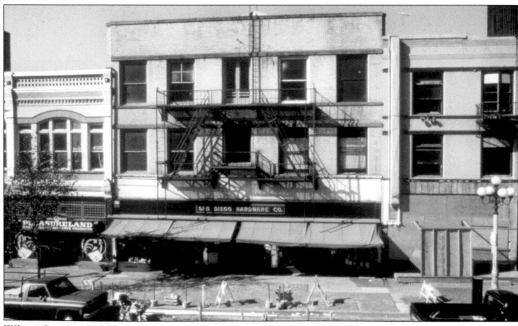

When San Diego Hardware, started by Fred Gazlay in 1892, took over this location, it retained Woolworth's signature curved display windows. The rounded windows provided increased area to display San Diego Hardware's many products. (GQHF)

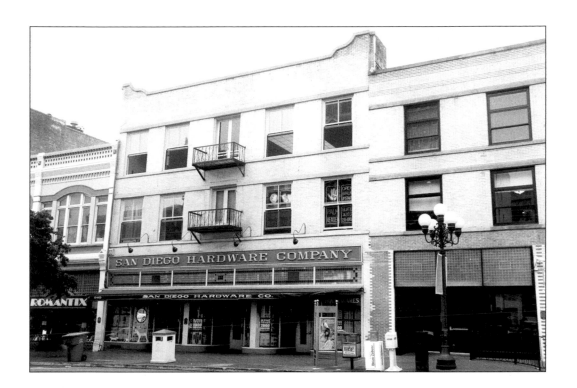

San Diego Hardware has survived all the eras of downtown San Diego, including the Stingaree, the stucco "modernization" of the 1950s, the adult-oriented uses of the 1970s, and the revitalization of the 1980s. Operated over 112 years by members of the Gazlay family, San Diego Hardware has the distinction of being the longest running family-owned business in the Gaslamp Quarter. In the mid-1900s, the fire escape was expanded, the store lettering shrank, and the roofline was flattened. An awning covered its distinctive leaded glass windows. After restoration, many negative changes were reversed. The building boasts its original hardwood floors and the Gaslamp Quarter's only original tin ceiling, as other building's ceilings were removed or donated as scrap metal for early war efforts. Walking Tour Building #25 (GQA-Silke)

Map not to scale

Broadway

N
W · E
S

E Street

25

4th Ave.
5th Ave.
6th Ave.

F Street

25. San Diego Hardware Bldg.
840 Fifth Ave.

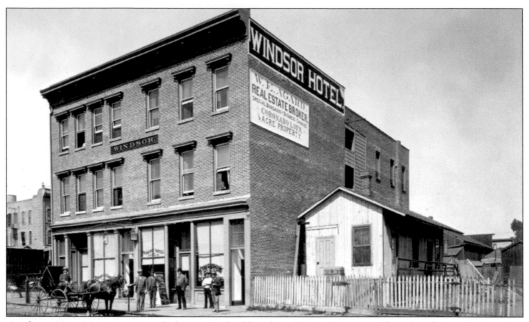

Andrew Van Horn acquired this parcel of land in 1884. Four months after his marriage, he deeded a portion of the lot to his wife in return for "conjugal love and affection." The Van Horns built the modest Windsor Hotel brick structure in 1887. The first floor once housed a pool hall, and upper floors contained over 30 small, comfortable rooms. This photo was taken in 1889. (©SDHS, #2865)

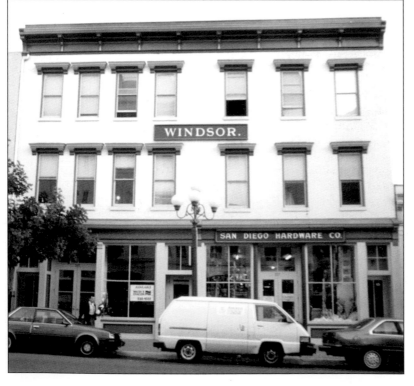

For a time in the 1920s and again in the 1990s, San Diego Hardware expanded into the first floor of the Windsor, which backs up to the San Diego Hardware building, providing convenient entrances on both Fourth and Fifth Avenues. In the 1960s, a nightclub, complete with go-go dancers, shared storefront space with a card room. This photo was taken c. 1980. (GQHF)

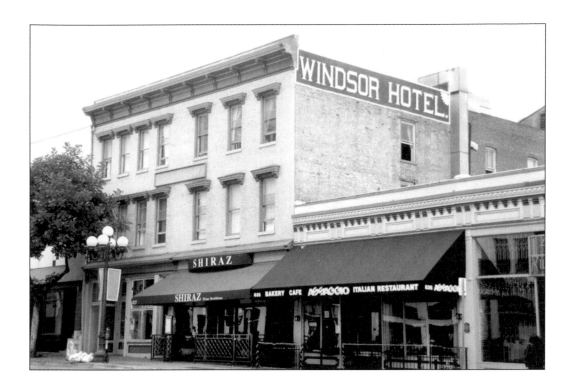

Not much has changed over the decades in this brick structure. The original brick was painted over on the facade at some point, but the Windsor Hotel mural, a Gaslamp fixture for over 100 years, has been restored. From 1910 to 1914, Mrs. Addie Davis was the hotel proprietor. A short list of women operators follow her, perhaps a hint at the type of business conducted upstairs. Today, the restored building houses a restaurant on the ground floor and apartments above. It is worthy to point out that an early tenant, Fred Heilbron of Nichols and Heilbron Steamfitters, became known later in life as "Mr. Water" for his efforts as a member of the San Diego Water Authority to bring Colorado River water to San Diego. Today, the building has retail on the ground level and residents above. Walking Tour Building #26 (GQA-Silke)

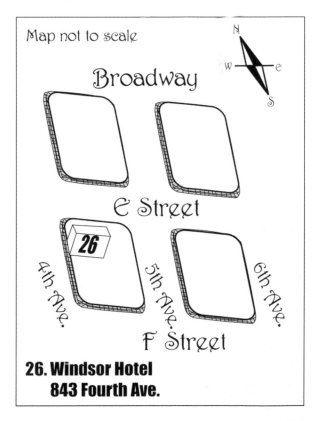

Map not to scale

Broadway

E Street

4th Ave.

5th Ave.

6th Ave.

F Street

26

26. Windsor Hotel
843 Fourth Ave.

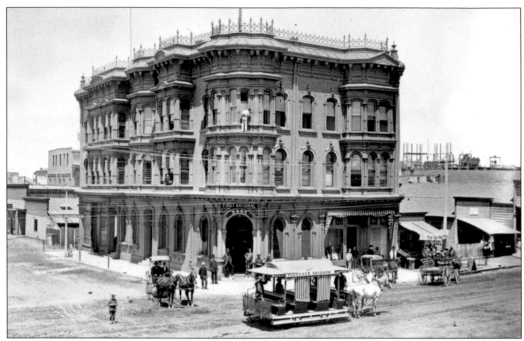

When originally constructed in 1884, the elaborately detailed Victorian First National Bank building was only one story. Two years later, two additional stories were added and First National Bank occupied the ground floor. The interior was quite opulent, with teller windows of burnished brass and French glass, and floors made of Italian marble. This photo was taken in 1887. (©SDHS, #2109)

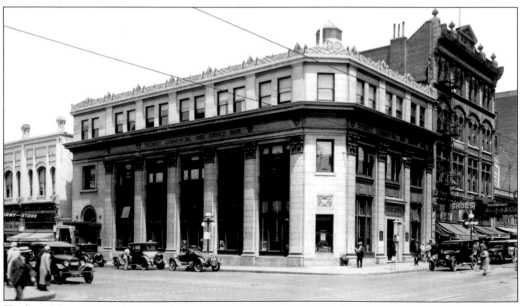

Trading Victorian styling for Baroque Revival architecture during a renovation in 1927, the building, seen here *c.* 1925, is hardly recognizable in this photograph when compared to its earlier appearance. Security Pacific National Bank operated in this location from 1922 until 1971. (©SDHS, #Sensor 5-175)

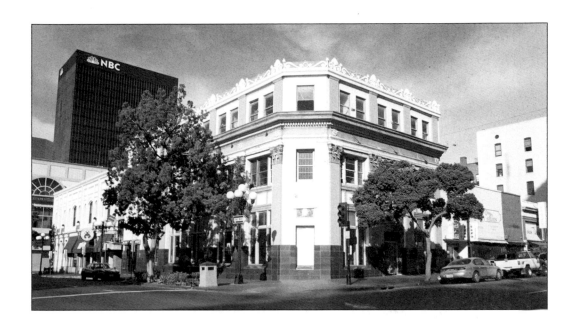

In 1973, Tom Hom and his brother Dr. George Hom purchased the building. Tom Hom was a former deputy mayor and San Diego assemblyman who, with others, spearheaded the effort to revitalize the dilapidated Gaslamp. While the changes to the building from its original appearance in 1884 to its renovation in 1927 are too numerous to detail, this structure greatly illustrates the contrast of two differing but uniquely beautiful architectural styles created from the same space. The building now houses a restaurant on the ground floor with upper floor offices. Walking Tour Building #27 (Courtesy Marvin Sloben Photography)

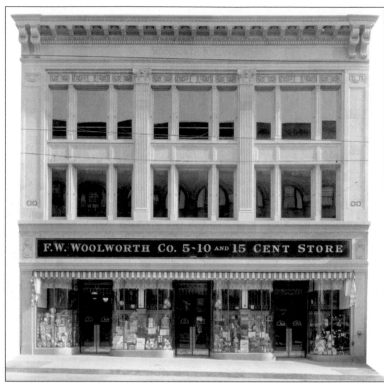

Moving "uptown" from their first San Diego store, Frank Woolworth of F.W. Woolworth Company, had the original 1886 brick and wood frame Victorian-style architecture modified to accommodate his burgeoning Five-and-Dime empire. The original Victorian bat windows were removed and replaced with four Corinthian pilasters in the tradition of the signature Woolworth windows. (©SDHS, #1998)

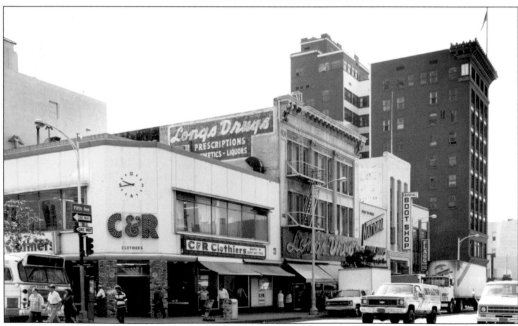

The Woolworth Company leased this building, second from the left, for over 50 years and used the second floor for offices. The third floor had furnished rooms. Eventually, the Five-and-Dime fell on hard times, as business shifted to suburban malls, and downtown retailers were less popular. Several businesses have had long stints since in this location, including Long's Drugs. This photo was taken in 1980. (©SDHS, #80:3059)

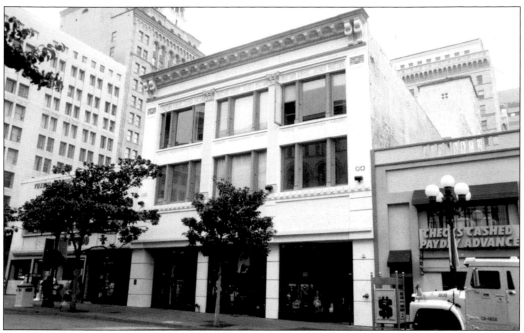

The Woolworth building was renovated in 2001 with the upper floors now serving as loft condominiums. Other than signage and awning changes over the years, the building still retains its original character from the 1922 remodel by Frank Woolworth. Of particular note are the detailed plaster castings and ornate roofline moldings. The Woolworth name can still be seen at the top, a gentle reminder of a time when something of value could be purchased for "five-and-dime." Walking Tour Building #28 (GQA-Silke)

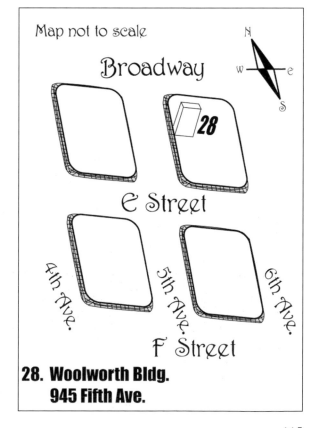

Map not to scale

Broadway

28

E Street

4th Ave.

5th Ave.

6th Ave.

F Street

**28. Woolworth Bldg.
945 Fifth Ave.**

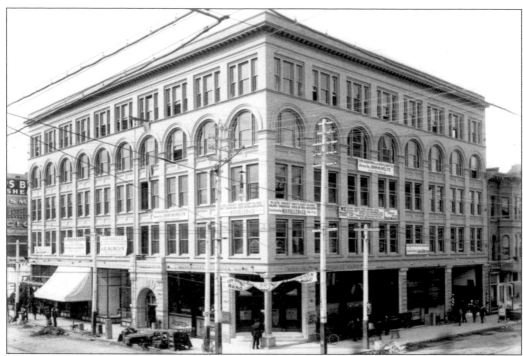

Ralph Granger, already a millionaire, arrived in San Diego in 1892 and constructed the Granger Building at a cost of $125,000. He had the good fortune of staking two German miners who discovered the Last Chance Silver Mine in Colorado. Granger was vice president of Merchants National Bank, which occupied the ground floor. This photo was taken in 1905. (©SDHS, #138)

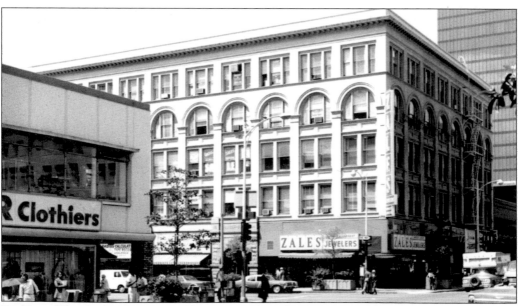

Dr. Harry Wegeforth, who operated his practice from the Granger Building, became founder of the San Diego Zoo. He traveled the world collecting specimens, sheltering animals in the basement of the Granger Building until the zoo was established in Balboa Park. Another notable tenant was J. Jessop & Sons Jewelers. This photo was taken in 1980. (©SDHS, #80:3295, detail)

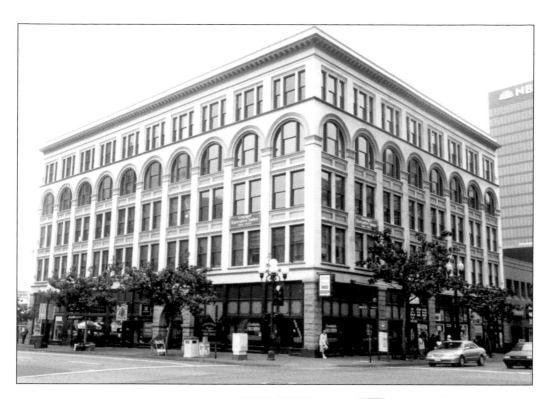

By 1924, Merchants National Bank had become the Bank of Italy, and eventually became Bank of America. By 1980, the clutter is gone, but it has been replaced with oversized storefront, signage hiding the building's beautiful detailing. In the earlier 1905 photograph nine banner-style advertisements clutter the appearance of the structure. Currently, the scale of the retail signs do less to obstruct the historic Romanesque architecture. The building is now mixed-use retail and office space. Walking Tour Building #29 (GQA-Silke)

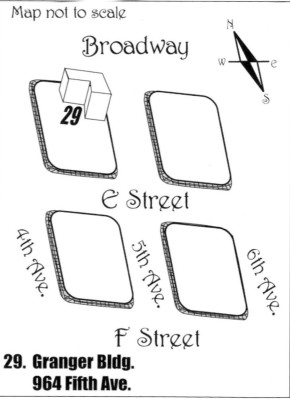

Map not to scale

Broadway

E Street

4th Ave.

5th Ave.

6th Ave.

F Street

**29. Granger Bldg.
964 Fifth Ave.**

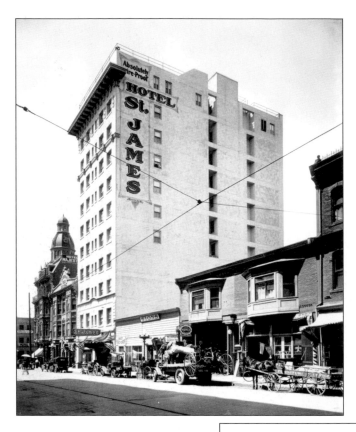

Pictured in 1914, the St. James Hotel was built in 1912 to capitalize on visitors expected for the 1915 Exposition in Balboa Park. It took 13 workers a little over one year to build the 11-story structure. They were paid in gold and worked 55 hours per week. The hotel boasted 146 rooms; appointments included a Turkish bath, billiard room, and fine views of the bay. (©SDHS, #7)

At the time it was built, this structure was the tallest in San Diego's skyline. The elaborate Pierce-Morse Building, seen in the background of this 1949 photograph, will soon disappear from San Diego's skyline. Hotel guests enjoyed two high-speed elevators, and management bragged the building was "Absolutely Fireproof." (©SDHS, #UT 8248-346)

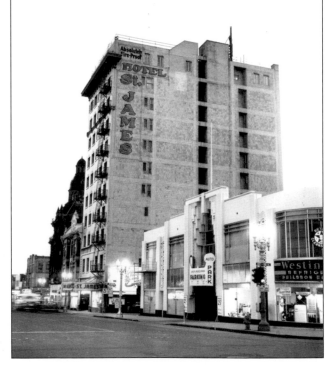

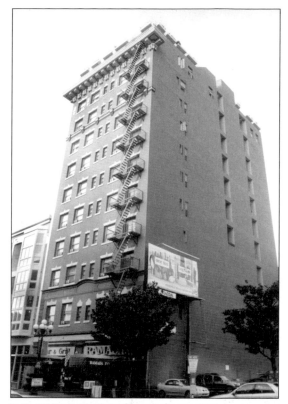

The St. James Hotel's lobby bar was purportedly owned by actress Joan Crawford. Legend has it she left heel marks on the bar while dancing on it one evening, and they are still there today. The St. James remains a fine hotel with spectacular views and an up-to-date interior. The lighted hotel sign facing west atop the building is a familiar downtown landmark. Walking Tour Building #30 (GQA-Silke)

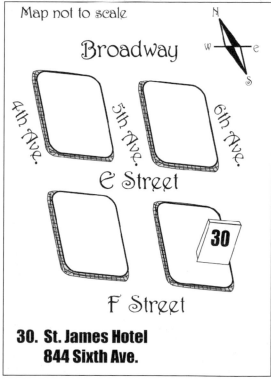

Map not to scale

Broadway

E Street

F Street

30. St. James Hotel
844 Sixth Ave.

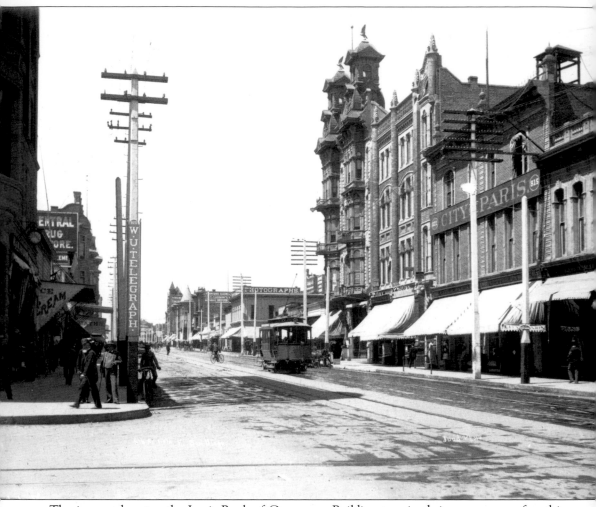

The iron eagles atop the Louis Bank of Commerce Building remained six more years after this photo was taken in 1898. They were destroyed in a 1904 fire and were not replaced for almost a century. (©SDHS, #21582)

Five

PRESERVATION AND CELEBRATION
Faces behind the Revival of an Historic District

This 1983 Gaslamp Quarter dedication celebrates the completion of many major infrastructure improvements to the Gaslamp Quarter Planned District. The Gaslamp Quarter was placed on the National Register of Historic Places in 1980. Mayor Pete Wilson sits to the right of the podium. (GQHF)

City staff, loan officer, and later Gaslamp Quarter property owner and developer, Dan Pearson developed the Horton Grand Hotel complex in relocating, reconstructing, and combining two historic downtown structures. His wife, Kit Goldman, pictured here, founded and operated two theatres in the Gaslamp Quarter. (GQHF)

A major developer of shopping centers throughout the western United States, Ernie Hahn's designs for Horton Plaza altered the face of downtown. Being a strong supporter of downtown redevelopment, he chaired the Downtown Planning Committee, creating the 1992 Centre City San Diego Community Plan, a blueprint for today's downtown San Diego. (©SDHS, DiGesu #B346)

Former City Council member, property owner, and developer in the early 1970s, Tom Hom led the effort to pull property owners and other interests together to convince the City to revitalize the Gaslamp Quarter National Historic District. (GQHF)

Mayor and eventually California governor, Pete Wilson made redevelopment of downtown San Diego a major part of his work in office. The Gaslamp Quarter was one of his four major projects for downtown. Horton Plaza, housing, and the San Diego Convention Center were the other three. The City of San Diego created Centre City Development Corporation in 1975 to rehabilitate downtown's infrastructure and help spur its economic development. In 1983, "The Fourth Avenue Project" in response to Horton Plaza, successfully matched up CCDC with Gaslamp property owners on Fourth Avenue to revitalize their properties. This photo shows the brick laying for the completion of the first public improvements at Fifth and G Streets. (GQHF)

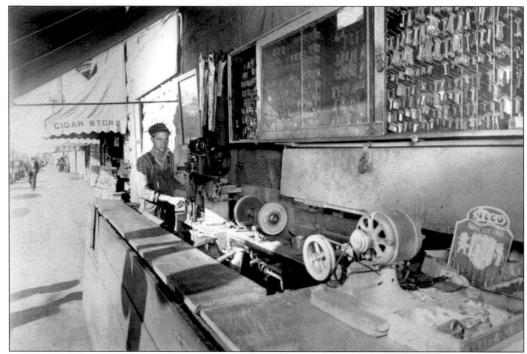

Armond Viora's stepfather Paul Valentino gave him the San Diego Key Shop in 1927, the same year this photograph was taken. The key shop, established in 1914, was first located inside the Keating Building lobby at 432 F Street. Shortly after Viora took over, the shop moved to a booth directly outside the entrance to the building at 430 F Street. (Courtesy Geneva Viora)

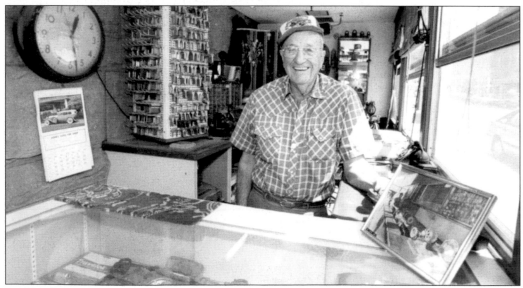

Armond Viora, pictured here in 1995, witnessed first-hand many of the significant changes in the Gaslamp Quarter documented in this book. San Diego mayor Roger Hedgecock proclaimed April 23rd Armond Viora day in San Diego for his good-natured spirit, expertise in the key craft, and his tenacity as a longtime Gaslamp business owner. Viora passed away in 1996. (Courtesy Geneva Viora)

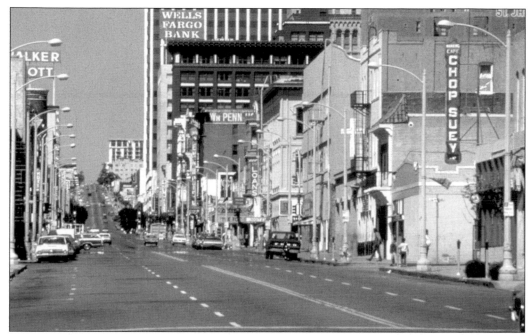

This photograph shows Fifth Avenue north from K Street *c.* 1980. The "Chop Suey" sign locates the Nanking Building at 467 Fifth Avenue, built in 1912 and recently restored. (GQHF)

Sidewalk infrastructure improvements commenced in 1980 when the City of San Diego made the Gaslamp Quarter a major redevelopment project. This Fifth Avenue street scene shows construction to remove paved sidewalks and replace them with brick pavers and signature Gaslamp streetlights. (GQHF)

Froebel "Fro" Brigham played the trumpet with national and San Diego jazz legends at Crossroads International Jazz Cafe at 761 Fourth Avenue. He is pictured here as a member of the Preservation Jazz Band on August 27, 1981. (©SDHS, #UT 91:R8179-21)

Gaslamp Square is pictured here in a view looking north to the Gaslamp Arch in the year 2000. Kay Carter spearheaded the effort to fund the gateway arch. A staff member of the Gaslamp Quarter Association, member of the Gaslamp Quarter Council, and chief of staff to City Council Member Byron Wear; Carter passed away in 2003. (©Travers-SDHS-2000/100.188)

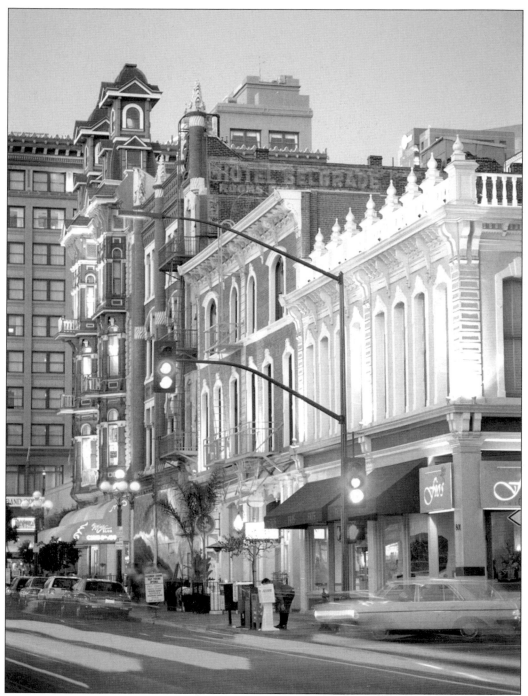

The Louis Bank of Commerce is among the most photographed buildings in all of San Diego and stands as a symbol of many who struggled to succeed in the area. Replica iron eagles were recast and reinstalled soon after this photograph was taken, and now sit once again, poised in their lofty position to observe the changes a new century will bring to San Diego's Gaslamp Quarter. (Courtesy John Durant, Photographer)

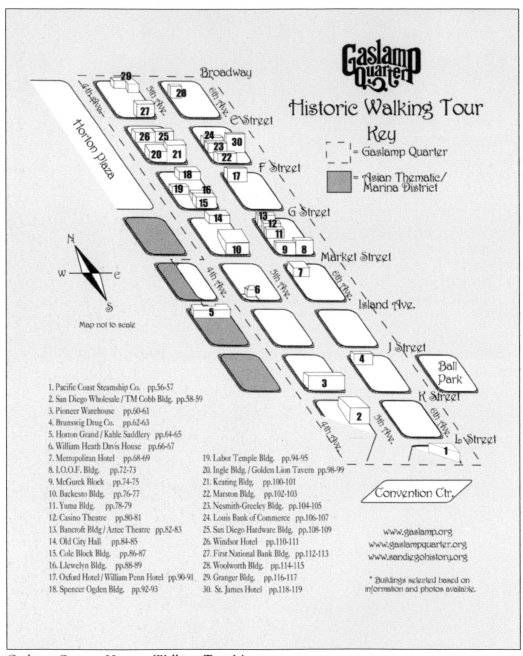

Gaslamp Quarter
Historic Walking Tour

Key
☐ = Gaslamp Quarter

▨ = Asian Thematic/ Marina District

Broadway

E Street

F Street

G Street

Market Street

Island Ave.

J Street

K Street

L Street

Horton Plaza

4th Ave.
5th Ave.
6th Ave.

Ball Park

Convention Ctr.

Map not to scale

N W E S

1. Pacific Coast Steamship Co. pp.56-57
2. San Diego Wholesale / TM Cobb Bldg. pp.58-59
3. Pioneer Warehouse pp.60-61
4. Brunswig Drug Co. pp.62-63
5. Horton Grand / Kahle Saddlery pp.64-65
6. William Heath Davis House pp.66-67
7. Metropolitan Hotel pp.68-69
8. I.O.O.F. Bldg. pp.72-73
9. McGurek Block pp.74-75
10. Backesto Bldg. pp.76-77
11. Yuma Bldg. pp.78-79
12. Casino Theatre pp.80-81
13. Bancroft Bldg / Aztec Theatre pp.82-83
14. Old City Hall pp.84-85
15. Cole Block Bldg. pp.86-87
16. Llewelyn Bldg. pp.88-89
17. Oxford Hotel / William Penn Hotel pp.90-91
18. Spencer Ogden Bldg. pp.92-93

19. Labor Temple Bldg. pp.94-95
20. Ingle Bldg. / Golden Lion Tavern pp.98-99
21. Keating Bldg. pp.100-101
22. Marston Bldg. pp.102-103
23. Nesmith-Greeley Bldg. pp.104-105
24. Louis Bank of Commerce pp.106-107
25. San Diego Hardware Bldg. pp.108-109
26. Windsor Hotel pp.110-111
27. First National Bank Bldg. pp.112-113
28. Woolworth Bldg. pp.114-115
29. Granger Bldg. pp.116-117
30. St. James Hotel pp.118-119

www.gaslamp.org
www.gaslampquarter.org
www.sandiegohistory.org

* Buildings selected based on information and photos available.

Gaslamp Quarter Historic Walking Tour Map.